Creative
Visual
Thinking

Creative
Visual
Thinking

HOW TO THINK UP IDEAS FAST

A system for art directors, designers, illustrators, photographers, account executives, copywriters, creative directors, editors, and publishers

By Morton Garchik

Art Direction Book Company, New York

1st Printing, 1982
2nd Printing 1985

Copyright © 1982 by Morton Garchik

Library of Congress Catalog Card Number: 81-66880
ISBN: 0-910158-80-0

Printed in the United States of America.

Published by
Art Direction Book Company
10 East 39th Street
New York, New York 10016

To Jean, Phil and Norma; and Janice.

Contents

Acknowledgments

Of the graphics reproduced in this book, *only the samples of my work were created with my system*. All the other reproductions in the book are used as outstanding examples of the Problem Solving Approaches (P.S.A.s). I neither imply or claim that my system was used to create them; obviously other professionals have their own methods.

I would like to thank all the artists, photographers, studios, agencies, copywriters, editors, publishers, account executives, and corporations who have kindly granted me permission to reproduce their work.

I am especially indebted to Laurence Oberwager for his professionalism and untiring help, and Gerda Lerner, for her encouragement.

Introduction

This is a how-to book.

Creative Visual Thinking (C.V.T.) is both a *verbal* and a visual skill. Though some people have a natural or intuitive ability to produce creative visuals without the conscious use of a verbalizing process, many people in publishing and advertising do not. This handicap hinders their careers. While they may think it is due to a lack of that "creative imagination" with which others are "born," it is actually due to a block.

In the case of some artists, their non-verbal tendency prevents them from developing a verbal thinking process. In the case of people who work with words—publishers, editors, copywriters, or account executives—their visual block is the result of their being too literal.

Creative visual thinking can be taught. This book teaches a system for training the mind in the step-by-step procedures necessary for producing vital, clever, eye-catching graphics, within the rigorous deadline demands of publishing and advertising.

The Creative Visual Thinking system works.

When I left art school and entered the world of commercial art, I received a rude awakening. Though I had been awarded prizes in drawing and illustration, I found that (a) I was only one of many who could draw well and (b) that the best jobs and advancement went to those who could *think* creatively. I had never been trained in that skill. I learned a little about creativity by apprenticing with professionals, but my learning was slow and haphazard. I enrolled in post-graduate courses, which claimed to teach creativity, but I found them unsatisfactory. What I needed was a *practical method for thinking up an idea.*

The C.V.T. system is that method. I developed it by studying and analyzing prize-winning graphic art, photos, illustrations, and ad copy. I tested the system for many years by using it to solve professional assignments, as both a free-lance and staff art director.

The System Can Work For You.

Chapter 1 contains five examples of professional assignments that I solved, using my system, and the basic *step-by-step mental process* used to arrive at the solutions. Additional examples of my work created with the system, with supplementary explanations, appear in other sections of the book.

All you have to do to make the system work for you is study and practice those step-by-step procedures.

Chapter 1

How the C.V.T. System Works

If you do not have the ability to create interesting visuals, you can learn. If you are an artist, the first step is learning to *think* before using your pencil; and then, to use your pencil for *writing*, before you begin to draw. If you start to draw before you think, you will tend to draw your old ideas. We are all habituated to the use of that which we already know. And that habit smothers creativity.

If you are a writer who cannot conceive visuals, you can learn by freeing yourself from thinking too literally.

The C.V.T. system will teach you methods that stimulate new ways of thinking. The system has many applications: editorial and adverising art, illustration, photography, logo design, video.

* * *

An essential part of the C.V.T. system is a working knowledge of the Problem Solving Approaches (P.S.A.s)—the names I have given to different methods of working on an assignment. It will suffice for the moment that you skim through the P.S.A.s and their accompanying illustrations in Chapters 2, 3, and 4. This will give you an overview of the diversity of approaches. By the time you complete this chapter, you will appreciate the necessity of either memorizing the P.S.A.s or having them at hand as you work on an assignment. They are the pathways to varied, but specific choices for creative exploration. Having those choices will lead you quickly to solutions—often unexpected and unusual ones.

Next, study the step-by-step examples that follow. They are actual on the job assignments, which I solved, using the system.

Then, master the method, by practicing those steps yourself, using the Practice Assignment given at the end of each example.

Example 1

Association

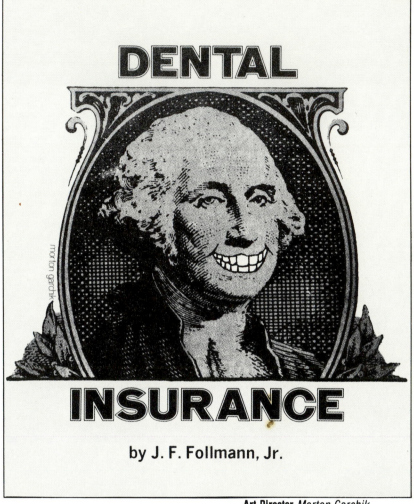

Art Director *Morton Garchik*
Illustrator *Morton Garchik*
Client *Communication Channels, Inc.*

This example simply utilizes the technique of word association (see also page 18).

Step 1 Write Down the Title

DENTAL INSURANCE
It sounds obvious and unnecessary, but it will keep you from overlooking even the most tangential association, which may suggest just the unique twist that solves your problem.

Step 2 Subdivide the Title into Individual Words and Word Combinations

DENTAL DENTAL INSURANCE INSURANCE

Step 3 Word Association & Word Lists

Under each of the words or combinations, make lists of words or ideas that you freely associate to them. Write down anything you associate, no matter how remote or insignificant, even cliches. Often, the most distant or innocuous association can be used to create an interesting graphic image:

DENTAL

drill	dentist	cavity	ouch	smile	toothpick
teeth	nurse	pain	toothpaste	dental floss	dentures
bridge	tooth	x-ray	tube	toothbrush	

DENTAL INSURANCE
- patient holding insurance policy
- insurance salesman handing policy to patient in dentist's chair
- patient showing dentist an insurance policy
- dentist's bill shown next to an insurance policy

INSURANCE

policy	slot machine	dollars	$ dollar sign	Lincoln
salesman	money	dollar bills	coins	
checks	cash	bills	Washington	

Step 4 List Scanning & Random Linking

Scan the Word Lists. As you do, connect words or phrases from one list with those of another list. Do this *randomly*, for example: take the first word on the list under DENTAL (drill) and combine it with any of the words on the list under INSURANCE: drill-policy, drill-salesman, drill-checks, etc.

Write down the combinations that have interesting visual possibilities, or, if you are working on a copy problem, those with catchy copy potential.

Step 5 Mental Doodling

Mentally Doodle, that is, make mental "roughs," inspired by the random word cross-fertilization. Jot these rough thoughts down.

In this example, my Mental Doodling went as follows (note, the italics indicate the randomly linked words or phrases):

"... president *Washington* holding a *dentist's drill* ... *dentures* clamped on *money* or *insurance policy* ... *three teeth* in *slot-machine* window, *insurance policy* coming out of pay-off slot ... *toothpaste* squeezed from *tube* in the form of a *$ sign* ... *dollar bills* coming out of the *toothpaste tube*..."

Several of these had potential, either as photo-montage or illustration. However, I chose still another possibility, the simple combination:

"... *money, Washington, teeth* ..."

My thinking continued like this:

"... first president's portrait on the *dollar bill* is an accepted symbol for money ... in this context, it can stand for *insurance* ... portrait can be altered to show *teeth* ... add to this the well known fact that Washington had severe dental problems..."

Step 6 Carrying the Idea One Step Further

(This step is not always needed, but was used in this instance).

Carrying your first idea One Step Further, is often the difference between an adequate solution and a sensational one. Don't pat yourself on the back and stop your thinking after the first good idea. Attack and prod it with the stimulation of a second P.S.A. In this example, the portrait could have been changed to include teeth, without altering the facial expression, and it would have worked. But, I carried this idea further, by reviewing the P.S.A.s and selecting Humor, as a possible approach, and then did more Word Associating and Mental Doodling:

HUMOR
cartoon	smile
laugh	grin

"... have Washington's teeth in a *smiling* mouth, and give the sober title a comic lift.

A Special Note to Artists

Unlike writers, your art skills—good at drawing people, or animals, or tight rendering, or type design, etc. can work against you. Even using the C.V.T. system, your tendency may be to lean toward solutions that you yourself can execute. Actual job assignments may indeed require that you deliver the complete package, idea and finished art. But, to get the most out of this book, approach the practice assignments as if the best specialists, with artistic skills other than you own, were available to execute the idea you have created.

Summary

Practice the following assignment using these steps, as explained above:
1 — Write Down the Title
2 — Subdivide the Title into Individual Words and Word Combinations
3 — Word Associate to the Title Words and Word Combinations, and Make Word Lists
4 — Scan the Word Lists and Link Words from List to List Randomly
5 — Mentally Doodle about the Combinations you select from Step 4
6 — Carry Your Idea One Step Further by selecting a supplementary P.S.A.

Practice Assignment

Try the step-by-step procedures with a similar title, "Hearing Insurance."

Example 2

Visual Metaphors & Visual Puns

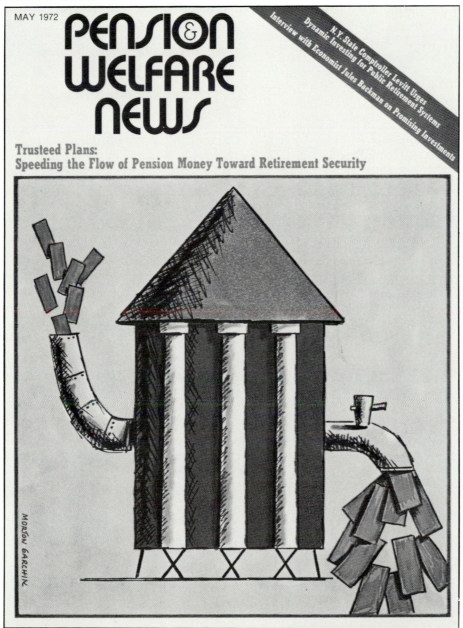

MAY 1972

PENSION & WELFARE NEWS

N.Y. State Comptroller Levitt Urges Dynamic Investing for Public Retirement Systems

Interview with Economist Jules Backman on Promising Investments

Trusteed Plans:
Speeding the Flow of Pension Money Toward Retirement Security

Art Director *Morton Garchik*
Illustrator *Morton Garchik*
Client *Communication Channels, Inc.*

This P.S.A. uses the interplay of verbal and visual metaphors. The Mental Doodling process is guided by the similarity between images, objects, or products, which can be combined, altered, or put in a new context, to create a unique visual conception that arouses surprise or humor in the beholder (see also page 62).

In this example, I will also explain another C.V.T. technique, Random Image Association.

Step 1 Write Down the Title

SPEEDING PENSION MONEY TOWARD RETIREMENT SECURITY
You will notice a discrepancy between this copy, which was the original title I was assigned, and the title as it appears on the printed piece. That is because the image I created for this cover story required a slight copy change so that both the copy and the picture would interact advantageously.

It is often helpful to consider changes in a title—of course, with the consent of the writer—if that change will enable you to create a more interesting image.

Step 2 Subdivide the Title into Individual Words and Word Combinations

SPEEDING	MONEY TOWARD RETIREMENT
SPEEDING PENSION MONEY	SECURITY
MONEY	

Supplementary Words & Phrases

Occasionally a title will not give you enough information. Even reading the article or story yourself may not help; it may be too technical, too specialized, or too scholarly. Ask the writer to explain the important points in simple language. Then add that information—in the form of Supplementary Words & Phrases—to your Title Word Combinations.

In this case, I was told that the article had to do with the movement of investment funds through banks, and with the increase in their value as a result of that movement. Thus, I added:

INVESTMENT FUNDS MOVE THROUGH BANKS
INCREASE IN VALUE, AS A RESULT OF MOVEMENT THROUGH BANKS

Step 3 Word Association & Word Lists

SPEEDING
cars blurry motion zzzooooom jet plane wings speedboat

SPEEDING PENSION MONEY
money on wheels money with wings 'running' (animated) money

MONEY
dollars $ signs gold silver banks teller cash flow

MONEY TOWARD RETIREMENT
● money 'flying' to pensioner, who is lying in hammock
● series of dates: 1989, 1990, 1991 etc. fading towards a horizon with a big $ sign in the background
● clocks, calendars, hourglass filled with money

SECURITY
happy old couple elderly surrounded by objects of prosperity

MOVEMENT OF FUNDS THROUGH BANKS
- carts of money wheeled through bank
- huge coins rolling through bank
- animated money 'running' through bank

INCREASE IN VALUE
AS A RESULT OF MOVEMENT THROUGH BANKS
- money growing on tree in bank
- 'mom' and 'pop' money holding lots of 'kids' monies

Step 4 List Scanning & Random Linking

You will recall from Example 1, in this step you randomly connect words from one list with those on another list, for example: cars-money on wheels; cars-$ signs; or zzzooooom-cash flow; or wings-gold, etc.

Though my Random Linking suggested many images, I could not find a Visual Pun, and so I proceeded to still another step in the C.V.T. system.

Step 5 Random Image Association

Gather a few picture books—advertising annuals, photo and illustration annuals. Browse through them, while intermittently Rescanning your Word Association Lists.

This is not a "swipe" search for some image that will fit your title. Rather, what you want is a quick scan of Random Images, some of which might mesh with each other; or with some of your Word Associations to create the Visual Pun. (While doing this, also keep in mind my definition of Visual Pun: images, objects, or products, which can be combined, altered, or put in a new context, to create a unique visual conception, that arouses surprise or humor in the beholder.

While scanning some books, a photo of a traditional bank building, with its triangular roof and classic columns, caught my attention. In doing Step 3, my mental image of *bank*, had been limited to that of the contemporary glass and steel variety. Now, I added the classic image to my thinking.

The next Random Image that caught my eye, happened to be right out my window — a huge, big-city roof-top watertower. The similarities of the traditional bank architecture and that of the watertower definitely had the makings of a Visual Pun. But, how to relate it to the title? I added water and watertower to the Word Lists, and Associated to them:

WATER
H_2O drink swim float flow ... cash flow! leak faucets
spigots pipes frozen pipes

WATERTOWER
rooftop city skyline pigeons

Step 6 Mental Doodling

First, I reviewed all the raw material compiled in the preceding steps. It did not take long for this sequence of thoughts to evolve and pull the ideas together:

"... *bank* and *watertower* combined into a unique image ... add to the new configuration, *pipes* and *spigots* ... *dollars (cash flow), move through* the "*bank—watertower,*" they go in small, and emerge large (*growth through movement*)"

All that remained was to sketch a rough, and suggest a slight copy addition, "... the Flow of ...," so that the headline would interact with the one-of-a-kind visual creation.

Summary

Practice the assignment below using these steps:
1 — Write Down the Title
2— Subdivide the Title into Individual Words and Word Combinations
3— Word Associate to the Title Words and Word Combinations, and Make Word Lists
4— Scan the Word Lists and Link Words from List to List Randomly
5— Do some picture browsing for Random Image Associations
6— Mentally Doodle about all the above raw material

Practice Assignment

Use the step-by-step procedures explained above to create a Visual Pun for the copyline: "Growing Oranges Around the World." Make a copy change, if it will enhance your idea.

Example 3

Symbol Combinations

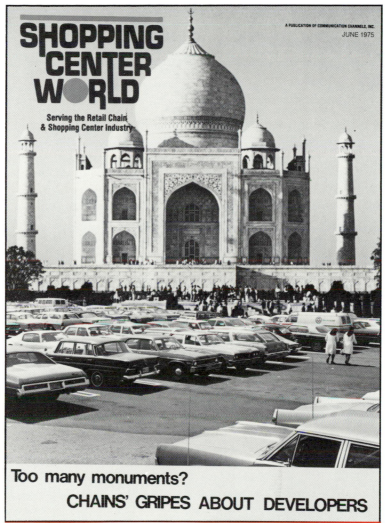

Art Director *Morton Garchik*
Collage *Morton Garchik*
Client *Communication Channels, Inc.*

Symbol Combinations is simply the combining of visual symbols, which are inspired by the Random Linking step. Avoid the cliches, by seeking out unlikely, but logical ideas. See also page 55.

Step 1 Write Down the Title

TOO MANY MONUMENTS?
CHAINS' GRIPES ABOUT DEVELOPERS
The gist of this full-color magazine cover story was that shopping centers were being built unnecessarily grandiose, with the extra costs being passed on to the unhappy tenants. The editor was after a satirical image—the ultimate, overbuilt shopping center (a "monument"). Thus, I only needed two subdivisions: one, a symbol of a great monument, the other, for a shopping center.

Step 2 Subdivide the Title or Symbol Words

MONUMENTS SHOPPING CENTER

Step 3 Word Association to Title Words or Symbol Words

MONUMENTS
pyramids Parthenon Colosseum St. Peters Taj Mahal
Notre Dame Washington Monument

SHOPPING CENTER
crowds of shoppers shops consumer products services
drive to the s.c. lots of cars parking lot

Step 4 List Scanning, Random Linking & Mental Doodling

In this case, my Mental Doodling was simultaneous with the Scanning and Linking:

"... the elegant and lavish *Taj Mahal* is the logical symbol for the overbuilt, extravagant, shopping center (a "monument") ... but how can I transform its appearance into that of a shopping center ...? One glance at the Word Association Lists, under shopping center, revealed that a huge *parking lot* would be as much a symbol of a shopping center, as a center itself, and would create just such a transformation."

I simply Photo-Montaged the two symbols, and the assignment was quickly completed.

Summary

Practice the following assignment using these steps:
 1 — Write Down the Title
 2— Subdivide the Title or Symbol Words
 3— Word Associate to Title or Symbol Words
 4— List Scanning, Random Linking & Mental Doodling

Practice Assignment

Use the step-by-step procedures above to create an image using symbol combinations for a music article entitled, "Too Many War-Horses Mute Modern Masters."

Example 4

Type as Object, Object as Type

Art Director *Morton Garchik*
Client *Communication Channels, Inc.*

The Creative Visual Thinking system can be applied successfully to typographic problems, as well as to pictorial ones.

In this approach, Scan your Word Association Lists for an object that can substitute as a letter in a word. Or design letters or words as an object or objects. (See also page 87.)

This assignment was to do a logo design. Its primary use was to be as a masthead for a full-color magazine cover, but it would also have to function in black and white and, in smaller sizes, on letterheads, business cards, and forms. This is how I applied the C.V.T. system to the problem.

Step 1 Write Down the Title

PENSION WORLD
This was another instance of requiring more information than that supplied by the title itself. The magazine, a financial publication, was concerned primarily with the *investment of pension funds for growth*. I concentrated on those words for Subdividing, Word Association, and Word Lists

Step 2 Subdivide

INVESTMENT OF PENSION FUNDS
FUNDS
FUNDS FOR GROWTH
GROWTH

Step 3 Word Association & Word Lists

INVESTMENT OF PENSION FUNDS
stock market stock page columns over the counter N.Y. Stock Exchange American Stock Exchange gold silver commodities rare coins antiques art rare books

FUNDS
piles of money dollar(s) coin(s) $ signs

FUNDS FOR GROWTH
appreciation up arrows pointing up

GROWTH
plants/leaves increase expansion

Step 4 List Scanning, Random Linking & Mental Doodling

Here are some of the Mental Doodles my List Scanning Random Linking generated:

"... Letter-forms could be made from *stock market page columns* silhouettes ... hand lettering, with stylized 'growth' shapes (*plants, leaves*) evolving from the 'I' in 'PENSION,' or curving off the end of the 'N' ... letter-forms derived from *arrow* motif, indicating growth movement ... letters, beginning very condensed, on the left end of the words PENSION WORLD and *expanding* as they move across the words to the right ... a *$ sign* for the 'S' in PENSION. ..."

To test these ideas out, I checked each against a set of criteria appropriate to this assignment:
Would the solution take advantage of full color reproduction?
Was it appropriate for this magazine's conservative audience?
Was it too gimmicky?
Was it a cliche?
Would it function in both small and large sizes?
I rejected my first group of Mental Doodles. But, the testing helped me to narrow down the choice of a specific P.S.A. I had had several of the Chapter 4 Typographic P.S.A.s in mind while doing the Mental Doodling. But, because of its simplicity, Object as Type now struck me as the most suitable approach to concentrate on. What was needed was an object, whose form or silhouette was easily recognizable and legible, and which could substitute for one of the letters in 'PENSION," or "WORLD" and which would symbolize money and growth. The "P," "I," or "O" were the likely shapes for substitutions. I Rescanned the Word Lists and resumed Mental Doodling. It did not take long to find:

"... *coin*, as a substitute shape for the 'O' ... what kind of coin? ... (more List Scanning) *gold*, the historically universal *growth investment* ... it will fill all requirements: reproduce well in full-color and black and white and in all sizes; it will enhance the title in a dignified manner, with the uniqueness that only gold has; thus it will appeal to a conservative readership. ..."

The problem was solved.

Summary

This example illustrates another feature of the C.V.T. system—flexibility. You need not necessarily select a P.S.A. at the beginning of an assignment.

Sometimes it is better to wait until you have done Steps 1, 2, and 3.

Practice the following assignment using these steps as explained above:

1 — Write Down the Title
2 — Subdivide the Title or Title Information into Individual Words or Word Combinations
3 — Word Associate to the above Word Combinations
4 — List Scan, Link Randomly & Mentally Doodle

Practice Assignment

Using the same approach, create "Object/Type" substitutions for letters in the title, "A Man For All Seasons."

Example 5

Metamorphosis

Retirement Country: What's It Like Out There?

W hen thinking of retirement, do you conjure up a picture of a gray-haired gentleman, pipe in mouth, sitting contentedly in a rowboat, fishing for bass; in the background, his wife happily basking on the clean, sun-drenched beach in front of their secluded, lake-front cottage?

If you live in the United States, that's probably what you see. It's one expression of the American Dream — illustrated frequently in ads for mutual funds, life insurance, and savings banks. Other nationalities undoubtedly have their own specialized concepts of what retirement ought to be like — perhaps skiing in the Alps; making wine in one's own small vineyard, or

playing bocci with the "boys."

But consider this question: do people really spend their twilight years in a paradise they once dreamed about, or is that dream a cruel hoax, beyond the grasp of most retirees? The answer is maybe. On the one hand, those with money and good health do settle down to the good life; on the other, those less fortunate usually cannot.

HEW data

The Department of Health, Education, and Welfare offers these statistics on the health problems of the aged, based on the activities of the 14,000,000 individuals receiving social security checks:

● About 85% of older persons not in institutions have one or more chronic conditions. Some of these oldsters — 20% — find it difficult to get around. And 8% need some help in getting from here to there.

● Older people spend more time in the hospital than younger people — 18 days per hospital stay versus nine days for those under 65. And, the odds the oldsters will be hospitalized in any one year are *twice* as great as they are for persons under 65.

● Oldsters are 13 times more apt to be wearing a hearing aid.

Health factors aside, here are some economic observations.

Any American on a large pension

38

Art Director *Morton Garchik*
Illustrator *Morton Garchik*
Client *Communication Channels, Inc.*

For this P.S.A. I let the dictionary definition guide my thinking. Metamorphosis—a striking alteration in appearance, character, or circumstance. (See also page 41.)

Step 1 Write Down the Title

RETIREMENT COUNTRY: WHAT'S IT LIKE OUT THERE?
This was an assignment to illustrate a magazine article, which discussed negative aspects of retirement: low fixed income, senior citizens shunted aside. I added these important Related Phrases to the Subdivided Title Words in the next step.

Step 2 Subdivide

RETIREMENT COUNTRY LOW FIXED INCOME SENIOR CITIZENS SHUNTED ASIDE

Step 3 Word Association Lists

RETIREMENT
country Florida Sun Belt California
old age pension social security
COUNTRY
farm animals horses cows pasture
chickens barns crops
LOW FIXED INCOME
poor poverty small pension no pension
SENIOR CITIZENS SHUNTED ASIDE
limited activity nursing home put out to pasture

Step 4 List Scanning, Random Linking & Mental Doodling

After the Scanning and Linking, my Doodling went something like this:

"... show old couple, but in an unusual transformation and/or setting ... who, besides old poor people, gets *shunted aside?* ... the sick, the mentally ill, old *animals!* (ties in with country, in 'Retirement Country,' of the title) ... draw an old couple, metamorphosed into *old cows*, fettered in a sparse *pasture* ..."

Its all there in the Word Association Lists.

Summary
Use the following steps to solve the assignment below:
1 — Write Down the Title
2 — Subdivide
3 — Make Word Association Lists
4 — Scan the Lists, Link Randomly & Mentally Doodle
If you get stuck, utilize the additional step of Random Image Association (see Example 2).

Practice Assignment

Come up with a cover illustration idea for a book titled, "Nuclear Energy, Cure or Curse?"

Chapter 2

Problems Solving Approaches (P.S.A.s)
Visual Ideas

The P.S.A.s are names given to various methods that can be used to solve layout, illustration, photography, and design assignments. They will help you to *think up an idea.*

This section illustrates examples in which the visual concept is essential to the solution's success. Study them, commit their names and functions to memory, or, at the least, have them handy for reference before beginning the Creative Visual Thinking (C.V.T.) steps.

Sometimes an assignment immediately suggests a specific P.S.A. Other assignments may not, in that case try this procedure:

First do Steps 1, 2 and 3:
1 — Write Down the Title
2 — Subdivide the Title and any other Related Phrases
3 — Make Word Association Lists
 Now, keep the P.S.A.s in mind, as you:
4 — Scan the Word Lists and Link Randomly & Mentally Doodle

 Often, at this point, you will find one or two P.S.A.s "leap" out, like answers looking for a question. They will guide and inspire your thinking—the ideas will flow.

5 Research and Link Random Images, if necessary.
6 Go One Step Further, if necessary—use an additional P.S.A. to help prod your initial ideas.

See Chapter 1 for detailed, step-by-step C.V.T. instructions.

Animation

Give life to inanimate objects by adding human or animal attributes to them. Attaching arms, legs, and faces to objects is an expedient means of animation. But, use the C.V.T. techniques, detailed in Chapter 1, to create more imaginative conceptions.

Art Director *Morton Garchik*
Illustrator *Morton Garchik*
Client *Communication Channels, Inc.*

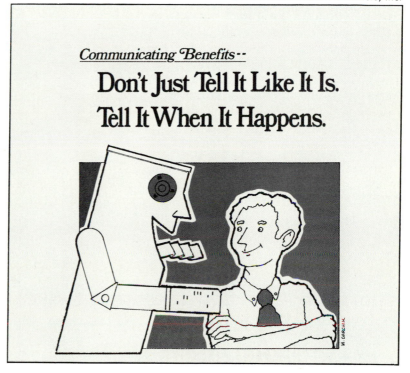

Illustrator *Morton Garchik*
Client *Harpers Magazine*

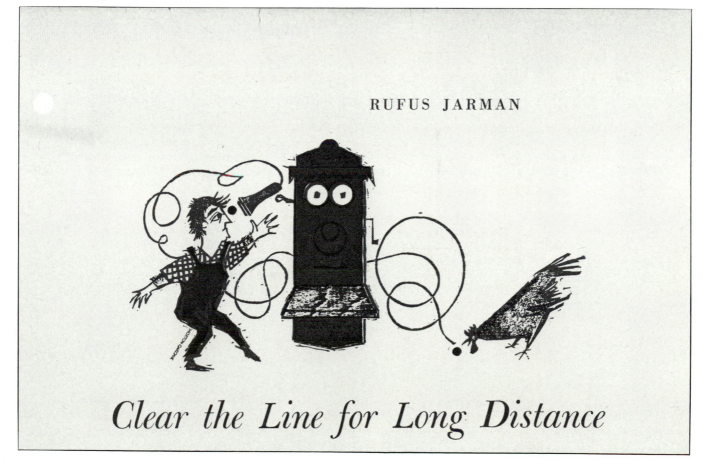

Association

Freely associate to a product and its attributes, the individual Words and Word Combinations in a headline or title, and any other Related Information. Follow up with Word List Scanning, Random Linking, Mental Doodling, and Random Image Association, if necessary. Your solution will really sing when you work out an image that is offbeat, but logical. (See detailed example, Chapter 1.)

Art Director *Carveth Hilton Kramer*
Illustrator *Jean-Francois Allaux*
Copywriter *Jack Horn*
Agency *Psychology Today Magazine*
Client *Psychology Today Magazine*

Art Director *Carveth Hilton Kramer*
Photographer *Carl Fischer*
Copywriter *Jack Nessel*
Agency *Psychology Today Magazine*
Client *Psychology Today Magazine*

up front

BLIND OBEDIENCE

BY HOWARD MUSON

"**Y**ou can get much further with kindness and a gun than you can with kindness alone," Al Capone supposedly said. Capone's insight was one of many offered at a recent symposium on "Obedience to Authority" at New York's Waldorf-Astoria Hotel. While the Chicago gangster knew human nature and (with Chairman Mao) the power of a gun, it is also true that authority compels respect for myriad other reasons.

For one thing, authority always must have a certain legitimacy. People obey it willingly, and at times, blindly, as we've learned from recent history. The most chilling aspect of Hannah Arendt's portrait of Adolf Eichmann was that he was not a sadistic killer but a rather ordinary man, a social climber who admired success and couldn't believe that the gods of the Third Reich were capable of evil. The Pentagon Papers, along with such events as My Lai and Watergate, have reminded us that even the most well-meaning individuals, when caught in the subtle snares of errant authority, do not usually resist.

I went to the Waldorf on a Saturday morning to find out what psychiatry and behavioral science could contribute to an understanding of this major concern of the 20th century. The conference was sponsored by the Harlem Valley Psychiatric Center of Wingdale, New York, and about 180 people showed up, lured partly by the offer of seven AMA-approved course credits and partly by a glittering panel, which included Herbert Spiegel, a psychiatrist and specialist in medical hypnosis; Thomas Szasz, by his own admission something of a civil disobedient within the psychiatric profession; Stanley Milgram, the psychologist whose experiments on obedience at Yale in the early 60s are famous; and—the feature attraction—John Dean, the former White House counsel, who could claim first-hand knowledge from his Watergate experience.

Dr. Spiegel launched the discussion on a rather disturbing note, with the suggestion that obedience may be biological in many cases. Spiegel, a professor of psychiatry at Columbia University, believes that people who are most susceptible to hypnosis also tend to accept control by others, uncritically, in various situations. He has developed a "hypnotic induction test," which he says can spot susceptibles by, among other things, measuring their ability to roll their eyeballs (upward and downward) on a one to five scale.

Those capable of high eye roll (the fours and fives) he calls "Dionysians," and those with low eye roll (the ones) "Apollonians." According to Spiegel, the Dionysians are, in general, influenced heavily by the right hemisphere of the brain, rich in imagination, trusting of others, and, he believes, easily led.

Stanley Milgram said the greatest lesson of 20th-century psychology was that obedience is determined not so much by the person and his moral qualities or lack of them, but by the situation in which he is placed. Most people cannot believe that they would act like the 65 percent of subjects in Milgram's experiments who were willing to give up to 450 volts of electric shocks to a confederate of the experimenter, in what was billed as a learning test, simply because the scientist in charge required them to do so. (No actual shocks were given, but the confederate displayed various signs of pain.)

Although some of the 65 percent themselves showed signs of discomfort and even protested, they continued to give the shocks, rationalizing their conduct in every possible way. "There was frequent dissent," Milgram says, "but that's not the same as disobedience. The subject was unwilling to appear rude. He did not want the experimenter to be embarrassed. He enters what I call an 'agentic state,' in which he sees himself as an agent of the experimenter. . . . The most difficult thing is to break the ice. Once the subject refuses to continue, his relationship with the experimenter changes. There is a perceptible moment when the strain is reduced; he appears to surmount a barrier of anxiety."

To Thomas Szasz, such nuances only obscure the basic truths. All authority needs willing subjects, whether slaves, passive citizens, mental patients, or drug addicts. Freud, Hitler, Nixon, and Stalin were alike in wanting to control people, according to the author of *The Myth of Mental Illness*. Most of mankind is willing to oblige, Szasz suggested. The only thing that can render authority unemployed, he added, is "self-control": the development of autonomy and independent judgment by each individual. (Continued on page 112)

Getting somebody to go to the dentist doesn't have to be like pulling teeth, according to pioneering researchers in the new field of behavioral dentistry. But students of dental phobias still have a lot to learn.

WHY DENTISTS ARE A PAIN IN THE MIND

By James Hassett

UNTIL A SHORT TIME AGO, dentists had little formal training to prepare them for the human side of their practices. The few lectures on psychology in the curriculum of most dental schools were usually delivered by a bearded Freudian who discussed the relationship between tooth extraction and castration anxiety, and went on to describe the sexual symbolism of the dental drill. Reactions among the students ranged from amused tolerance to open hostility, and this brief exposure to psychoanalytic theory had little impact on dental procedures.

Behavioral-management techniques, when they were taught at all, were appallingly primitive. Some professors of pediatric dentistry, for example, suggested that difficult children could be managed by the "towel technique"—stuff a towel in the child's mouth until he quiets down.

Then a small group of crusaders came along, armed with degrees in both psychology and dentistry. They brought scientific rigor and behavioral sophistication to an often skeptical audience of dental clinicians. Now, just a few years later, the Young Turks are deans at several of the nation's dental schools, and behavioral dentistry, like its cousin behavioral medicine, is beginning to make converts.

Last October, the pioneers gathered at West Virginia University for the first National Conference on Behavioral Dentistry. There they discussed various research projects aimed at easing dental phobias, minimizing pain in the dental chair, and breaking such habits as toothgrinding. They also spoke of the ways in which behavioral techniques might help people avoid dental problems.

Dental disease, one of the most widespread of human diseases, is also one of the most preventable. It is here that the link between dentistry and the social sciences is most obvious. After all, isn't it the business of psychologists to get people to change their ways? Yet, despite the fears of some journalists that mad behavior modifiers have the power to control us all, social scientists do not know enough to offer dentists much help. They can't even get people to brush their teeth three times a day.

Behavioral dentistry is an infant branch of psychology that is often characterized more by the enthusiasm of its advocates than by substantial findings. But, for the first time, researchers are asking the right questions, and dentists may soon begin helping for the human problems that have confronted them ever since they first began pulling teeth in barbers' chairs.

Dental Phobias

Psychologist Douglas Bernstein was afraid of the dentist. So, like 10 million other Americans, he simply stopped going. He blames his fear on a dentist he had as a child, who, he says, "thought that the use of Novocaine would lead to harder drugs." Years later, a bad toothache finally drove Bernstein to another dentist, one who believed in anesthetics. Now he sees his dentist twice a year, and almost enjoys it.

Bernstein, who teaches at the University of Illinois, was lucky. While some dental phobics can be cured by a single positive experience, many require more elaborate treatment. He is now collaborating with Ronald Kleinknecht of Western Washington University on studies of dental phobias—where they come from, how to measure them, and what can be done about them.

Studies show that about 6 percent of the people in the United States don't go to the dentist because of fear. Psychologists Bernstein and Kleinknecht trace much of this fear to early unpleasant experiences with a dentist. They asked 225 college students to write essays about their early experiences with dentistry and how they felt about dentists. Fifty-eight percent of the comments were negative, but the percentage of bad memories was much higher among those who, as adults, had a great fear of dentists. One such student wrote, "My first dental experience was just awful. I remember my mouth being stretched out of proportion, pain in the tooth, saliva by the gallons, spit on the dentist's glasses, the high pitch of the drill. Bad smells, bad vibes." Said another, "I couldn't help but liken the dental instruments to those used on the innocents during the Spanish Inquisition. I have an abiding distrust of needles, especially when the person wielding one is hiding it behind his back."

In contrast, another student who is not at all frightened by the prospect of a visit to the dentist had a pleasant memory to report: "Our dentist was a funny, balding man who called us funny names and always gave us a popsicle with a plastic tooth on the end." Another low-fear subject reminisced: "My dentist was patient and gentle and seemed to

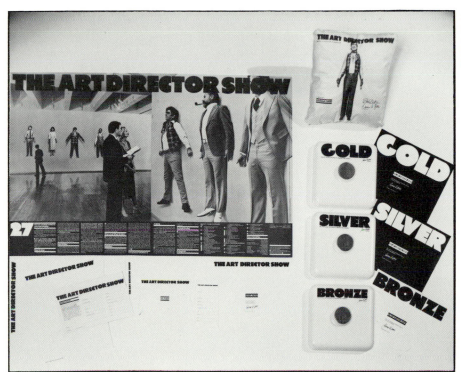

Art Director *Dan Bittman*
Photographer *Corson Hirschfield*
Illustrator *Maurice Delegator*
Agency *Sive Associates, Inc.*
Client *The Cincinnati Art Directors Club*

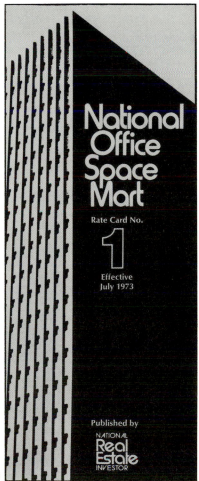

Art Director *Morton Garchik*
Client *Communication Channels*

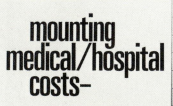

are the
money
managers
looking at
your
common
stock...
or
overlooking
it?

Art Director *Morton Garchik*
Illustrator *Morton Garchik*
Client *Communication Channels, Inc.*

Art Director *Morton Garchik*
Photographer *Morton Garchik*
Client *Communication Channels, Inc.*

mounting
medical/hospital
costs–

the health security act by leonard woodcock

The search for answers to the health care problem has been going on for some time now. I think the answers will be ... ship of the insurance industry to a partnership with the worker. ... medical economist Odin Anderson of the University of Chicago report-

Art Director *Morton Garchik*
Copywriter *Morton Garchik*
Client *Communication Channels, Inc.*

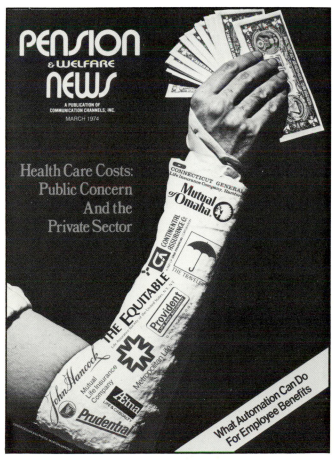

Art Director *Morton Garchik*
Photographer *Morton Garchik*
Client *Communication Channels, Inc.*

Cartoons

Give your unconventional ideas the humorous license of a Cartoon. Find the ideas with the C.V.T. system. My 'third arm' cartoon developed from Word Association to the Related Information "who will pay the bill?" The Mental Doodling went like this: "... *insurance co. ... government ... union ... big brother ... handouts ... helping hand!* ... draw an extra hand. ..."

Art Director *Ron Anderson*
Illustrator *Lou Meyers*
Copywriter *Tom McElligott*
Agency *Bozell & Jacobs, Inc. Minn.*
Client *Northwestern Bell*

Art Director *Charlie Abrams*
Illustrator *Charles Saxon*
Copywriter *George Rike*
Agency *Doyle Dane Bernbach, Inc.*
Client *General Wine & Spirits Co.*

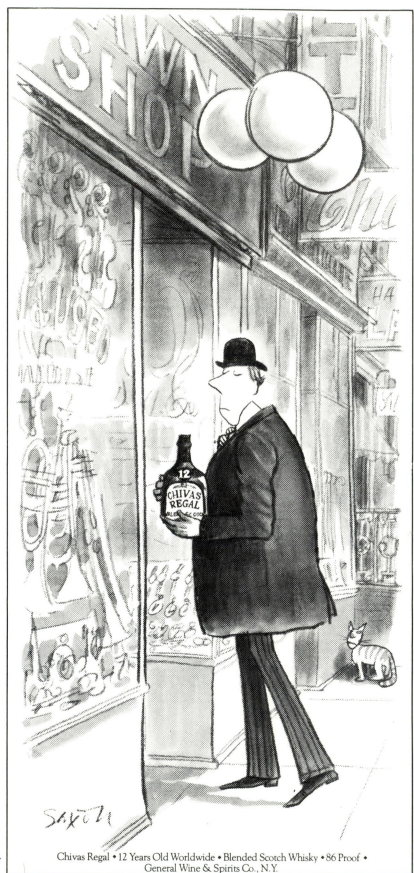

Chivas Regal • 12 Years Old Worldwide • Blended Scotch Whisky • 86 Proof • General Wine & Spirits Co., N.Y.

Drug Payment Plans Meet Wide Welcome

by Alvin Konigsberg

"There is something missing in what we call a free health care service if—at the end of the line—the member has to pay for his drugs. What if he can't? What then?

"At the National Maritime Union we see health care as a total package and we see the payment for drugs as much a part of our obligation as the payment for every other part of our health care delivery to all of our members."

The statement is from Shannon Wall, president of the NMU, and it typifies the growing awareness in many labor organizations all over the country concerning the final link in the health care chain that guarantees union members freedom from worry wherever and whenever illness strikes.

Union drug plans are still relatively new. The oldest one in existence is a little more than 13 years of age. But great strides have been made in that intervening span and most observers feel it is an idea whose hour has come. Presently some 4,000,000 union members and their families are covered by one variation or another of this benefit. The projection are that the figure will be doubled by 1980.

In a brief review of its yesterdays, it is interesting to note that it wasn't until 1967 that PENSION & WELFARE NEWS published what was perhaps the first exploratory study of prescription plans in North America.

Its edited version was taken

Art Director *Morton Garchik*
Illustrator *Morton Garchik*
Client *Communication Channels, Inc.*

Close-Ups & Cropping

Give a familiar product, object, person, or scene unusual eye-grabbing power by zooming in on a part of it, and enlarging it dramatically. In the case of Close-Ups the concept is usually indicated by the art director before the photo or illustration is executed. In Cropping, the art director might be given a complete illustration or photo with the assignment. Then, she/he decides to crop it to achieve the dramatic impact of a close-up.

Art Director *John Berg*
Photographer *Don Hunstein*
Agency *CBS Records*
Client *CBS Records*

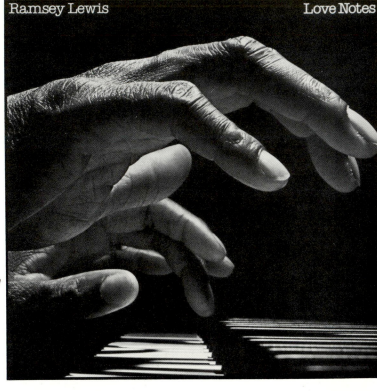

Ramsey Lewis Love Notes

Art Director *Joel Sobelson*
Photographer *Hiro*
Copywriter *David Miranda*
Agency *McCann-Erickson*
Client *L'Oreal*

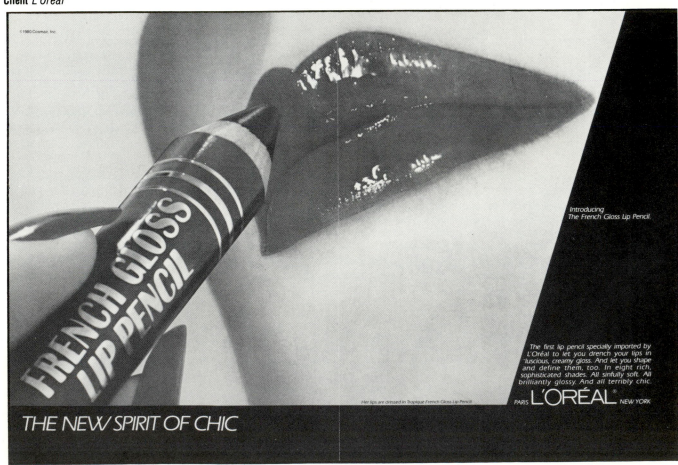

© 1980 Cosmair, Inc.

FRENCH GLOSS LIP PENCIL

THE NEW SPIRIT OF CHIC

Introducing
The French Gloss Lip Pencil.

The first lip pencil specially imported by L'Oréal to let you drench your lips in luscious, creamy gloss. And let you shape and define them, too. In eight rich, sophisticated shades. All sinfully soft. All brilliantly glossy. And all terribly chic.

Her lips are dressed in Tropique French Gloss Lip Pencil.

PARIS **L'ORÉAL®** NEW YORK

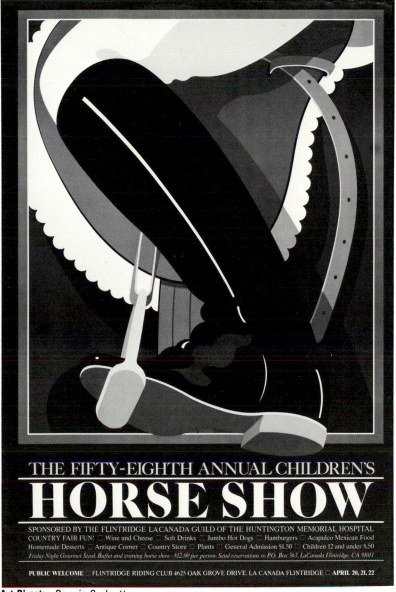

Art Director *Dennis S. Juett*
Illustrator *Jeff Lawson*
Copywriter *Dorothy A. Juett*
Agency *Dennis S. Juett & Assoc., Inc.*
Client *Flintridge La Canada Guild of Huntington Memorial Hospital*

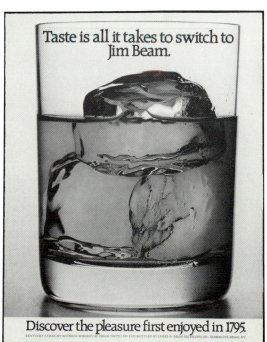

Art Director *Marcus Kemp*
Photographer *Dennis Manarchy*
Copywriter *Ken Bailey*
Agency *Lee King & Partners*
Client *James B. Beam Distillery*

HAVE WE GOT A PIN-UP FOR YOU!

Headliners wants you to get ready for their new wall chart. It's hot off the press and ready to hang in that open space on your office wall. No space you say? Well, one of the nicest features about their latest production is that it's bigger than ever, but only in what they've put into it, not in size. They've combined seven layered pages for easy visual use and even though it's now over four times larger in content it takes less space than just one old chart!

There's pages of sans faces, pages of serif faces, scripts and decorative Morgan types, even a textype page showing the latest in Headliners body types. There's all you'd expect plus a fabulous selection of new and exciting faces to keep the old standards company.

So let Headliners make the most of that space on your wall and in your ads with a fantastic new showing of all their faces that will guarantee you the best choice and great art.

HEADLINERS

Art Director *Howard Rogers*
Copywriter *Howard Rogers*
Illustrator *Sphere Design*
Client *Headliners International Inc.*

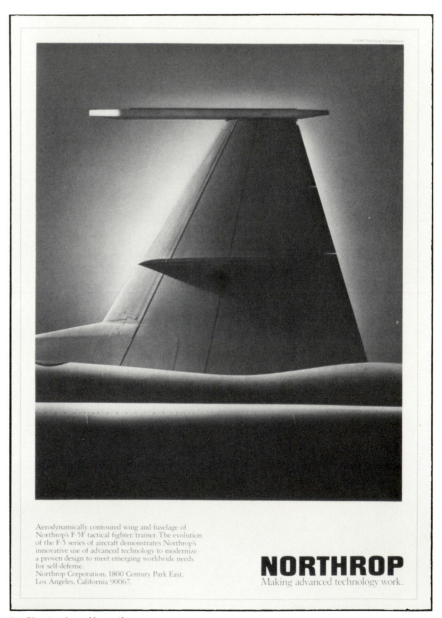

Aerodynamically contoured wing and fuselage of Northrop's F-5F tactical fighter/trainer. The evolution of the F-5 series of aircraft demonstrates Northrop's innovative use of advanced technology to modernize a proven design to meet emerging worldwide needs for self-defense.
Northrop Corporation, 1800 Century Park East, Los Angeles, California 90067.

NORTHROP
Making advanced technology work.

Art Director *Ivan Horvath*
Photographer *Per Volquartz*
Copywriter *Gil Lumbard*
Agency *Needham Harper & Steers Advertising, Inc.*
Client *Northrop Corp.*

Collage & Photomontage

Paste pieces or photographs or other graphic material together to form a unified, composite picture. Of course, *what pieces?*, will be answered by Random Linking combinations derived from your Word Association Lists, coupled with photo and art research.

Art Director *W.O. Bonnell*
Agency *Container Corporation of America*
Client *Container Corporation of America*

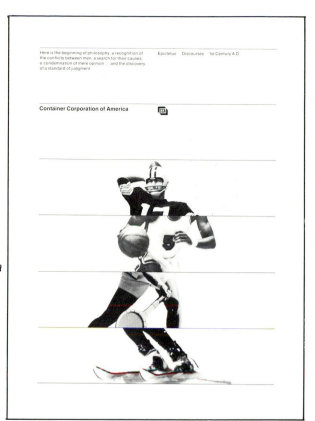

Here is the beginning of philosophy: a recognition of the conflicts between men, a search for their causes, a condemnation of mere opinion... and the discovery of a standard of judgment. Epictetus Discourses 1st Century A.D.

Container Corporation of America

Art Director *Morton Garchik*
Client *Parents' Magazine Press*

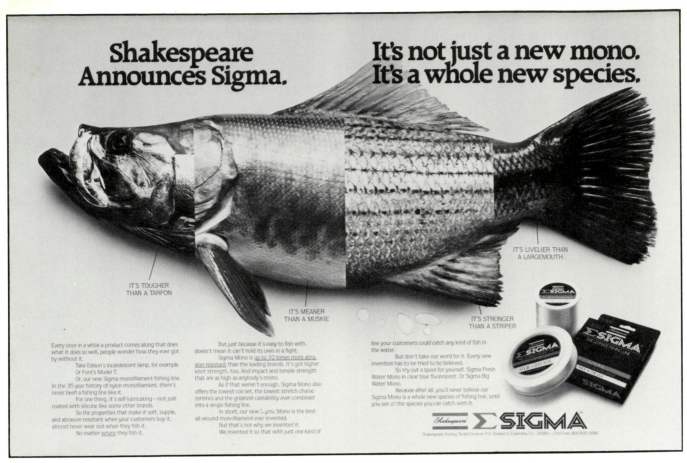

Shakespeare Announces Sigma.

It's not just a new mono. It's a whole new species.

IT'S TOUGHER THAN A TARPON

IT'S MEANER THAN A MUSKIE

IT'S LIVELIER THAN A LARGEMOUTH

IT'S STRONGER THAN A STRIPER

Every once in a while a product comes along that does what it does so well, people wonder how they ever got by without it.

Take Edison's incandescent lamp, for example. Or Ford's Model T.

Or, our new Sigma monofilament fishing line. In the 35-year history of nylon monofilament, there's never been a fishing line like it.

For one thing, it's self-lubricating—not just coated with silicone like some other brands.

So the properties that make it soft, supple, and abrasion-resistant when your customers buy it, almost never wear out when they fish it.

No matter where they fish it.

But just because it's easy to fish with, doesn't mean it can't hold its own in a fight.

Sigma Mono is up to 10 times more abrasion-resistant than the leading brands. It's got higher knot strength, too. And impact and tensile strength that are as high as anybody's mono.

As if that weren't enough, Sigma Mono also offers the lowest coil set, the lowest stretch characteristics and the greatest castability ever combined into a single fishing line.

In short, our new Sigma Mono is the best all-around monofilament ever invented.

But that's not why we invented it.

We invented it so that with just one kind of line your customers could catch any kind of fish in the water.

But don't take our word for it. Every new invention has to be tried to be believed.

So try out a spool for yourself. Sigma Fresh Water Mono in clear blue fluorescent. Or Sigma Big Water Mono.

Because after all, you'll never believe our Sigma Mono is a whole new species of fishing line, until you see all the species you can catch with it.

Shakespeare Σ SIGMA

Shakespeare Fishing Tackle Division, P.O. Drawer S, Columbia, S.C. 29260—(Toll Free) 800-845-2680

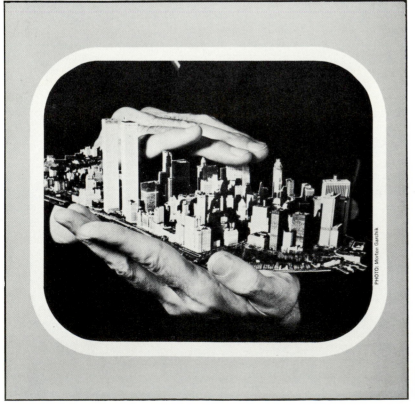

PHOTO: Morton Garchik

Comic Strip, Sequence, Storyboard

Give your basic idea or image the magnetism of a "moving picture," by dividing it into a series of dramatic or humorous evolving episodes.

Art Director *Morton Garchik*
Illustrator *Morton Garchik*
Client *Communication Channels, Inc.*

Art Director *Morton Garchik*
Illustrator *Morton Garchik*
Client *Communication Channels, Inc.*

Art Director *Marc Dorian*
Photographer *Gail M. Ross*
Agency *Marc Dorian, Inc.*
Client *Curtis Instruments, Inc.*

Art Director *Michael Fountain*
Illustrator *Lou Brooks*
Lettering *Michael Doret*
Copywriter *John Connelly*
Agency *Rumrill-Hoyt Inc.*
Client *Peters Div. of Remington Arms Co.*

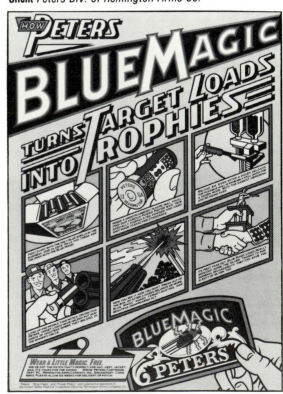

Decoration

Enliven headlines, titles, or art-work with rules, borders, ornaments, variations in type faces, exotic type faces, bendays, textures, patterns.

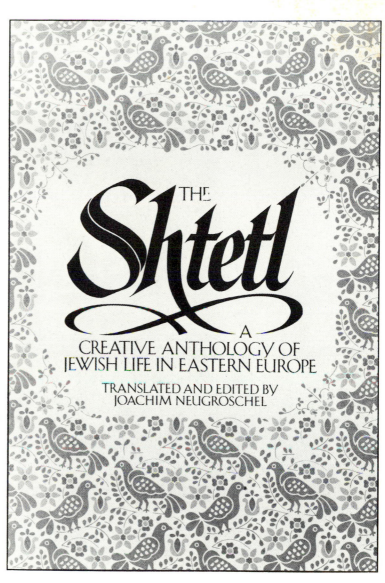

Art Director *Lynn Hollyn*
Calligraphy *Sol Novins*
Illustrator *Muriel Nasser*
Client *Richard Mareck Publishers*

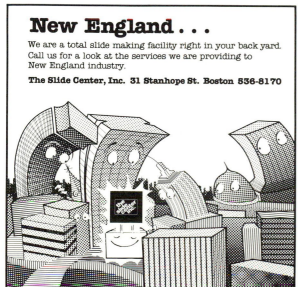

Art Director *Jonathan Sachs*
Illustrator *Mary Lyn McVoy*
Copywriter *Jonathan Sachs*
Agency *The Slide Center*
Client *The Slide Center*

SHOPPING CENTER WORLD

VOLUME 1 NO. 5 JUNE 1972

☆ ☆ ☆ ☆ ☆ ☆ ☆ ☆ ☆ ☆ ☆ ☆ ☆ ☆

WANTED! ALIVE

☆ ☆ ☆ ☆ ☆ ☆ ☆ ☆ ☆ ☆ ☆ ☆ ☆ ☆

PEOPLE

TO LEASE, DEVELOP, FINANCE, PROMOTE, AND MANAGE

800 NEW CENTERS EACH YEAR!

☆ ☆ ☆ ☆ ☆ ☆ ☆ ☆ ☆ ☆ ☆ ☆ ☆ ☆

Industry leaders tell how they train, promote, encourage, and lure the professionals they need.

☆ ☆ ☆ ☆ ☆ ☆ ☆ ☆ ☆ ☆ ☆ ☆ ☆ ☆

Art Director *Morton Garchik*
Illustrator *Morton Garchik*
Client *Communication Channels, Inc.*

Disguising

If your subject has a unique shape or silhouette, or a high recognition factor, create an intriguing image by disguising it. In addition to the Chapter 1 techniques, guide your thinking with questions like: "How can I alter the subject's usual Context?" "How can I mask details, but retain the identifying shape or silhouette?"

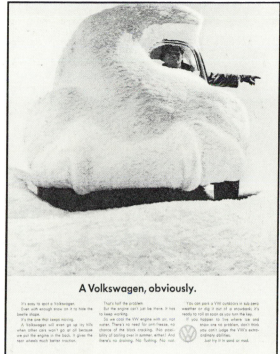

A Volkswagen, obviously.

Art Director *Helmut Krone*
Photographer *Wingate Paine*
Copywriter *Bob Levenson*
Agency *Doyle Dane Bernbach*
Client *Volkswagen*

Art Director *Allan Beaver*
Photographer *Carl Fischer Photography, Inc.*
Copywriter *Larry Plapler*
Agency *Levine, Huntley, Schmidt, Plapler & Beaver*
Client *Jockey International, Inc.*

Distortion & Exaggeration

Both approaches are wonderful attention-getters. Some clues for your Mental Doodling: enlarge the small, reduce the big, elongate the wide, expand the thin, melt the solid, harden the soft. Exaggeration lets you retain the elegance and sophistication of a subject, while avoiding the possible grotesque effects of Distortion.

Designer *Bob Pellegrini*
Photographer *Ryszard Horowitz*
Agency *Robert Miles Runyan & Assoc.*
Client *Richton International Corp.*

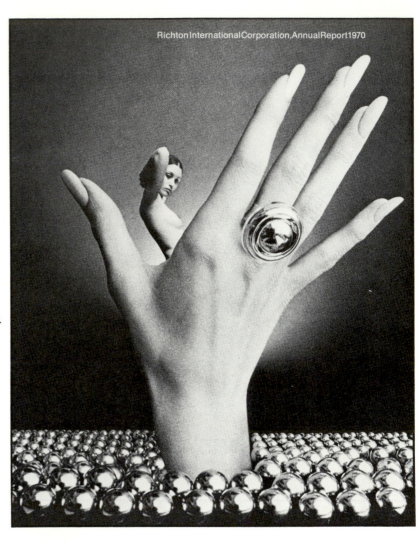

Richton International Corporation, Annual Report 1970

Design Director *Bob Guccione*
Art Directors *Frank Devino, Lynda Chyhai*
Illustrator *Fernando Botero*
Client *OMNI Publications*

"Double-Exposure"

Execute your Random Linking combinations as double-exposure images. Other sophisticated photo techniques—special lenses and filters—in addition to computer-generated images and animation offer diverse possibilities.

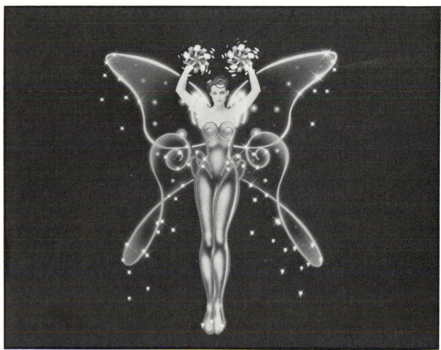

Art Director *Mitchell Brisker*
Photographers *Richard Corbin, Ross Kelsey, Richard Cohen*
Illustrators *Tom Steele, Peter Sato*
Animators *Duncan Majoribanks, Russ Moony*
Production House *Robert Abel & Assoc.*
Agency *Dentsu Advertising*
Client *Renown Clothing*

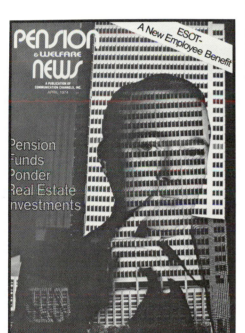

Art Director *Morton Garchik*
Photography *Morton Garchik*
Client *Communication Channels, Inc.*

Animation Director *Paul Jessel*
Illustrator *Dan Chessher*
Agency *Young & Rubicam-Detroit*
Client *Manufacturers National Corp.*

Fantasy

Give your imagination full rein when Word Associating, Random Linking, Mental Doodling, and Random Image Searching. Think in terms of: make-believe, capriciousness, whimsy, fancy, the supernatural, charming distortions, mixtures of realism and abstraction, and combinations of graphic techniques. (See also Visual Metaphors & Visual Puns, Surrealism.)

Art Directors *Onnig & Freddie Fields*
Illustrator *Jacqui Morgan*
Agency *Onnig Inc.*
Client *Creative Management Assoc.*

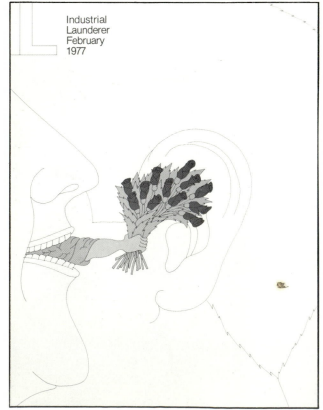

Industrial
Launderer
February
1977

Art Director *Jack Lefkowitz*
Illustrator *Jack Lefkowitz*
Copywriter *Jim Roberts*
Agency *Jack Lefkowitz Inc.*
Client *Institute of Industrial Launderers*

Fine Art

Select an existing fine art image (print, painting, sculpture, mosaic, quilt, ceramic, etc.) that can be wedded to a headline or title. Screen your Word Association Lists carefully for appropriate and subtle connections.

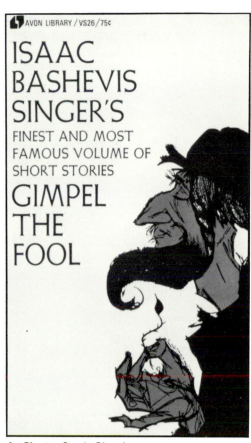

Art Director *Sandy Blough*
Illustrator *Morton Garchik*
(Woodcut: Courtesy: Associated American Artists)
Client *Avon Books*

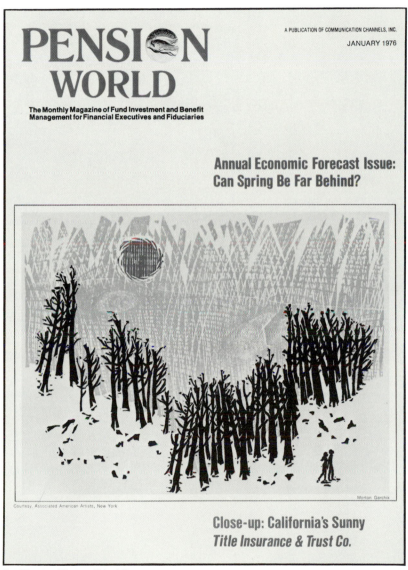

Art Director *Morton Garchik*
Illustrator *Morton Garchik (Woodcut, Courtesy: Assoicated American Artists)*
Client *Communication Channels Inc.*

Art Director *James Cross*
Photographer *James Cross*
Agency *James Cross Design Office, Inc.*
Client *American Institute of Graphic Arts*

Geometric Design

Transform a product, object, or type into a stark, geometric design. The guiding principle is simplicity —reinterpret the subject, using only straight and/or curved lines or shapes.

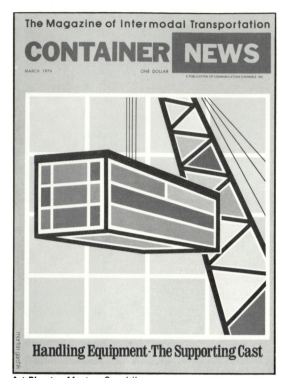

Handling Equipment-The Supporting Cast

Art Director *Morton Garchik*
Illustrator *Morton Garchik*
Client *Communication Channels*

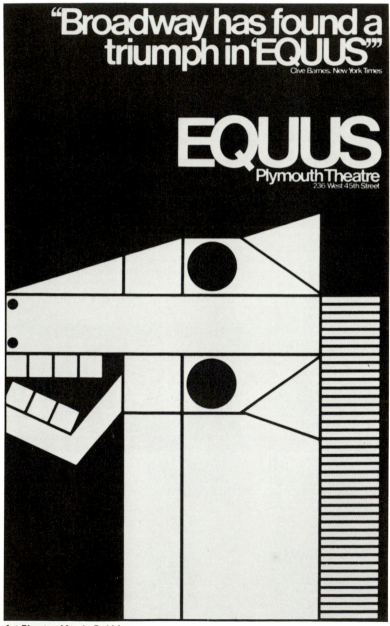

Art Director *Morris Robbins*
Illustrator *Gilbert Lesser*
Copywriter *The Equus Company*
Agency *Blaine Thompson*
Client *Equus Company*

Humor

This approach can take many forms (see also: Cartoons, Tall Tales, Double Entendre & Puns, and Word Play). Extensive Word Association Lists and Mental Doodling are essential. In some cases Literary Research is required: Lists of Famous Quotations, Current Slogans, Current Song and Book Titles, Proverbs.

(The agency has a policy of not supplying individual names since there is an emphasis on teamwork.)
Agency *Grey-Phillips, Bunton, Mundel & Blake (Pty) Ltd.*
Client *Hendlers Office Furniture*

Art Director *Nancy Hames*
Illustrator *Pete Bastiansen*
Agency *Kamstra Communications, Inc.*
Client *Neenah Paper Division, Kimberly-Clark Corp.*

Star light, star bright, take a star with you tonight. If you wish you may, you might. Just ask at the library. Silent films, sound films, film-strips with records – slapstick, adventure, things you'd like to see and know. Over 1300 titles make quite a choice – and make space a reel problem. But with the new library…that's a different story. Along with bigger and better facilities for all library services, it'll hold a bright film future. Stars for you today, stars tomorrow.

Open the book to Marion's future.
VOTE FOR YOUR NEW LIBRARY

Citizens for the New Library Clyde Fobes, Chairman.

Sing shorter songs.

THE gas COMPANY

Metamorphosis

(See Chapter 1 for a detailed analysis.) Keep the dictionary definition of metamorphosis—a striking alteration in appearance, character, or circumstance—in mind while doing your Mental Doodling. Be alert for off-beat but interesting combinations when you do your Random Linking. (See also Fantasy, Surrealism, Visual Metaphors & Visual Puns.)

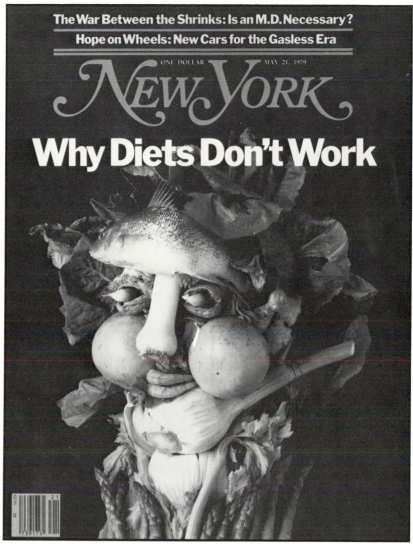

The War Between the Shrinks: Is an M.D. Necessary?

Hope on Wheels: New Cars for the Gasless Era

ONE DOLLAR MAY 21, 1979

NEW YORK

Why Diets Don't Work

Design Director *Jean-Claude Suares*
Art Director *Ellen Blissman*
Construction & Photo *Matthew Klein*
Client *New York Magazine*

Retirement Country: What's It Like Out There?

When thinking of retirement, do you conjure up a picture of a gray-haired gentleman, pipe in mouth, sitting contentedly in a rowboat, fishing for bass; in the background, his wife happily basking on the clean, sun-drenched beach in front of their secluded, lake-front cottage?

If you live in the United States, that's probably what you see. It's one expression of the American Dream — illustrated frequently in ads for mutual funds, life insurance, and savings banks. Other nationalities undoubtedly have their own specialized concepts of what retirement ought to be like — perhaps skiing in the Alps; making wine in one's own small vineyard, or playing bocci with the "boys."

But consider this question: do people really spend their twilight years in a paradise they once dreamed about, or is that dream a cruel hoax, beyond the grasp of most retirees? The answer is maybe. On the one hand, those with money and good health do settle down to the good life; on the other, those less fortunate usually cannot.

HEW data

The Department of Health, Education, and Welfare offers these statistics on the health problems of the aged, based on the activities of the 14,000,000 individuals receiving social security checks:

● About 85% of older persons not in institutions have one or more chronic conditions. Some of these oldsters — 20% — find it difficult to get around. And 8% need some help in getting from here to there.

● Older people spend more time in the hospital than younger people — 18 days per hospital stay versus nine days for those under 65. And, the odds the oldsters will be hospitalized in any one year are *twice* as great as they are for persons under 65.

● Oldsters are 13 times more apt to be wearing a hearing aid.

Health factors aside, here are some economic observations.

Any American on a large pension

38 **PENSION & WELFARE NEWS**

Art Director *Morton Garchik*
Illustrator *Morton Garchik*
Client *Communication Channels Inc.*

Non-Verbal Image

This approach is related to Fantasy, Surrealism, Visual Metaphors & Visual Puns. But, it is unique: though we can describe the image, often, we cannot describe the strange emotional response it evokes in us.

These creations are usually the province of very talented specialists, but if you want to try, look for interesting twists or combinations in your Random Linking, then go One Step Further, by searching for still another twist or combination.

Art Director *Geoffrey Moss*
Illustrator *Geoffrey Moss*
Copywriter *The Washington Post Writers Group & Geoffrey Moss*
Client *The Washington Post*
Original: *Collection of Dan Rather*

Art Director *Geoffrey Moss*
Illustrator *Geoffrey Moss*
Copywriter *The Washington Post Writers Group & Geoffrey Moss*
Client *The Washington Post*
Original: *Collection of Dan Rather*

Designer *Bob Pellegrini*
Photographer *Ryszard Horowitz*
Agency *Robert Miles Runyan & Assoc.*
Client *Richton International Corp.*

Outstanding Photograph

This P.S.A. requires that the art director and copywriter *respect the photographer's creativity.* Give it the whole stage and spotlight; restrain yourself, subdue the copy and layout.

Designer *Dorothy Fall*
Photographer *Christopher Springman*
Agency *U.S. International Communication Agency*
Client *America Illustrated Magazine*

Art Director *Peter Barbieri*
Photographers *John & Marilyn Bicking*
Copywriter *Alan Helfman*
Agency *Warner Bicking & Fenwick, Inc.*
Client *Ilford Inc.*

Parody

Imitate well-known images or copy for humorous or poetic effect. (Get permission from the publication, corporation, or people you are parodying.)

Art Director *William McCaffrey*
Copywriter *Adrienne Claiborne*
Agency *William McCaffrey Inc.*
Client *Paul Stuart*

THE ELEMENTS OF STYLE

(Some advice on dressing well gleaned largely from Strunk and White)

IT'S easy to say what style is not. It is not, for example, fashion. (See Rule 1, below.) But when a friend asked us, the other day, to say what it is, the only answer we felt sure of was: our bread and butter. Perhaps because that answer was true, our inability to define the word rankled. So at last, prompted by some half-remembered sentences, we reached for our copy of The Elements of Style.*

This useful little book, as anyone who took Freshman English within the last twenty years probably knows, was written by William Strunk, Jr., and revised by E.B. White. Mr. White also added the final chapter, and it was there we found him describing style as "what is distinguished and distinguishing." That seemed a dandy definition to us. It certainly described what we look for in clothes. It also sent us hunting through the pages for other remarks which, perhaps with the change of a word or two, might shed as much light upon style in dress as they did upon style in writing. We found them. And you can find them below, together with some remarks of our own. Most of them are merely observations or reminders, but we phrased them as rules to preserve the book's flavor. Should the reader wish to know which rules are whose, we suggest he reach for his own copy of the little book.

RULE 1. Don't confuse style with fashion.

To recognize the difference, consider the Nehru jacket. When it came into fashion here, the men who wore it were all, presumably, fashionable. But it rarely conferred much style.

RULE 2. Don't confuse style with substance.

A coat that is cashmere on the hanger continues to be cashmere when it's worn. But style may appear or disappear with the wearer; when Nehru wore it, the Nehru jacket had style.

RULE 3. Don't imagine that time governs style.

Time only governs fashion. If you doubt this, look at some old portraits.

Unless you are familiar with the period, you won't know if the subject's clothes are in fashion. But you will know at once if they had style.

RULE 4. Choose some clothes that are not in fashion.

Clothes that are in fashion one year are often out the next. But clothes that are too distinctive merely to echo current dictates, provided they are not so different as to be eccentric, often anticipate fashion or remain independent of it. And, if well suited to the wearer, they will go on being distinguished and distinguishing year after year.

RULE 5. Avoid tame, colorless, hesitating, noncommittal clothes.

They may seem to offer safety by promising to say nothing about the wearer. But, by being anonymous, they say that he is timid, indecisive, and without a sense of style.

RULE 6. Avoid the pretentious, the exaggerated, the coy, and the cute.

Those first two words are tricky. Kings may wear ermine without offense. And there are men who can carry off a scarlet-lined opera cape or a ten-gallon hat. But if wearing such things makes you feel as though you are showing off or masquerading, don't. As to the coy and cute, we feel queasy when we see an adult male in love beads.

RULE 7. Be sparing of the tried and true.

Good serviceable clothes, like good serviceable words and phrases, become dull and ineffectual when used too of-

ten in the same way. A few familiar classics may give a friendly ease to your wardrobe. But a wardrobe built entirely of classics is as tiresome as a vocabulary of clichés.

RULE 8. Remember that style is an increment in dress.

When we speak of a writer's style, we don't just mean his command of the relative pronoun. When we say a man dresses with style, we don't just mean we like the cut of his shirts.

RULE 9. Never sacrifice comfort to style.

The result is always self-defeating. Clothes that make you fidget can not be worn with style. If the coat pinches at the waist or the armhole, or rides up at the back of the neck, don't buy it. Or have it remedied. (We have a large staff of fitters to make sure the clothes we sell fit as they should.)

RULE 10. Dress in a way that comes naturally.

But don't be afraid to experiment; even Fred Astaire probably felt uneasy the first time he put on tails. Every well-dressed man, by the way he dresses, reveals something of his spirit, his habits, his capacities, his bias. So choose the clothes you are drawn to naturally. You will wear them better, and more often, than those you talk yourself into because they seem practical or look well on somebody else. But you may not find them in our store.

The clothes we carry reflect our spirit, our bias, our temperament. We collect them, just as we collect clothes for ourselves. If we find six sweaters of some wonderful kind, we'll buy them, even though six are all there are.

That sort of thing can make shopping in our store something of a treasure hunt. But it also means we can make no pretense of being able to dress every stylish man. To wear our clothes, Anthony Eden would have had to unbend a bit, Charles de Gaulle to lose some of his starch, and we doubt that we could ever have outfitted Adolph Menjou at all.

*The Elements of Style, Third Ed., by William Strunk, Jr. and E. B. White, MacMillan Publishing Co., Inc. 1979

Paul Stuart

Discover DeSoto Ask 10 people who DeSoto is. The over-40's will probably tell you it's a car, and the youngsters will say "a Spanish explorer." The point is, DeSoto is not exactly a household word in furniture. But since the recent furniture markets, if you ask some of the retail furniture leaders they'll tell you something is up at DeSoto Furniture. With capability and capacity that is rare in this industry, we have

embarked on a course of professionalism that is also unusual in furniture. In manufacturing. In design. And in marketing. We are carefully developing a total line concept in dining room, bedroom and occasional tables. With understandable good taste in design. Not "far out." And not as "knock-off artists.

With quality and substance at a price the average American can can afford. And with warehouse inventory that gives you continuity on your floor without tying up every cent you own.

TEST DRIVE A '75 DESOTO

⊙ DeSoto

Art Director *Joe Pizzirusso*
Illustrator *Jim Osborn*
Copywriter *John Malmo*
Agency *John Malmo Advertising Inc.*
Client *De Soto Furniture*

ED NUSSBAUM

BIG LEAGUE CHEWING GUM

Art Director *Ed Nussbaum*
Copywriter *Ed Nussbaum*
Illustrator *Ed Nussbaum*
Agency *Self-Promotion*
Client *Ed Nussbaum*

Repetition With Variation

A classical art technique that yields compelling, rhythmic designs. Your Mental Doodling should include: the look-alike similarities between different objects; the rhythm created by grouping different objects of the same size; the creation of a format for the presentation of different products, people, or ideas. Some examples: frames, borders, windows, color shapes, hands (holding the products).

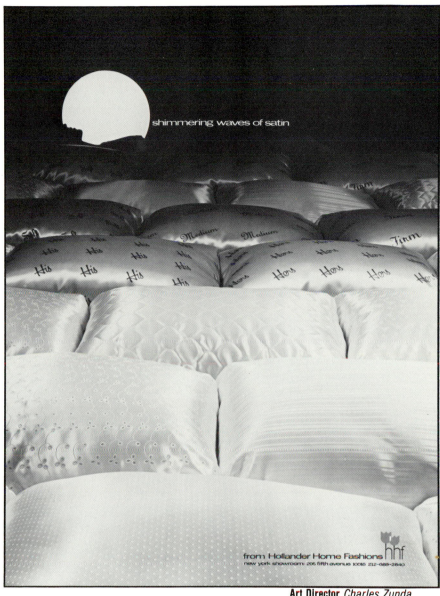

shimmering waves of satin

from Hollander Home Fashions hhf
new york showroom: 206 fifth avenue 10016 212-689-2840

Art Director *Charles Zunda*
Photographer *Bob Thomas*
Copywriter *Ed Stern*
Agency *Mark Color Studios*
Client *Hollander Home Fashions*

Art Director *David Gauger*
Photographer *Ernie Friedlander*
Copywriters *Mary Rudnicki Orr, David Gauger*
Agency *Gauger Sparks Silva*
Client *Westbrae Natural Foods*

Sensory Reaction

A dazzling Problem Solving Approach. Evoke an emotional reaction in the viewer by creating an image that jolts the senses through an empathetic response. This is another instance where you have to go One Step Further.

Example: your assignment is a storyboard for a title sequence to a TV film entitled, "Noise Pollution: Its Toll on Children." Your Word Lists would of course include: *child, ears, fingers in ears, hammering, jet plane noises, traffic noises, etc.* You might focus on the Random Linking of *child's ear* and *hammering;* your Mental Doodling would go like this:

"... how can I show noisy hammering affecting a child's hearing, without it looking like a gory murder ...?"

The Step Further in this case means—finding a substitute for the child, a stand-in, which can evoke the Sensory Response, without the gore. More Word Associating to *child,* and more Mental Doodling would then bring you to ideas like these:

"... FIRST FRAME—long shot of a lovely, delicate, *porcelain sculpture of a child's head* (the stand-in); SOUND—silence.

"... SECOND FRAME—Long shot of hammer, pounding on anvil; SOUND—noise of hammering, in distance.

"... THIRD FRAME—Camera moving closer to child's (sculpture's) head; SOUND—hammering noise is getting louder; add noises of engines, sirens, horn honking, jet planes, etc.

"... Continue alternating: closer to the child's head; closer to the hammer on the anvil; SOUND—increase volume of noises.

"... NEXT TO LAST FRAME—Close-up of sculpture-child's ear; hammer whacks it off!; SOUND—crescendo to deafening level.

"... FINAL FRAME—(slow motion) ear shatters, fragments fall; SOUND—cacophony. FREEZE FRAME of falling ear fragments; SOUND—sudden silence!"

Art Directors *Bob Farber/Toni Ficalora*
Photographer *Toni Ficalora*
Client *Toni Ficalora*

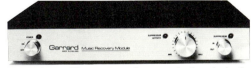
Art Director *Constance Kovar*
Photographer *Central Reproduction & Photography*
Copywriter *Nathan Pitt*
Agency *Lincoln, Pitt & Associates*
Client *Garrard Division,*
 Plessey Consumer Products

Shocker

Create an image that jolts the viewer by the use of: startling elements, the unexpected, the incongruous, the unthinkable. Use unusual, but logical Random Linking. (See also the related P.S.A.s: Collage, "Double-Exposure," Distortion & Exaggeration, Fantasy, Metamorphosis, Non-Verbal Image, Surrealism, and Visual Metaphors & Visual Puns.)

Art Director *Aric Frons*
Photographer *Cosimo*
Copywriter *Frank N. Mecca*
Agency *Harvard Peskin & Edrick, Inc.*
Client *Aurea*

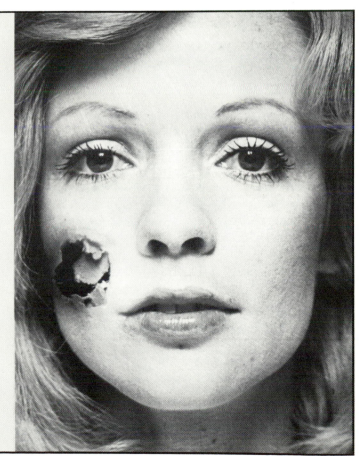

FIRST STEPS TO SAVE A FACE

ALTHOUGH YOU MAY NOT think of facial injuries as life-or-death emergencies, a badly smashed face is usually the result of a really serious traumatic encounter. And the first ten minutes after such a patient is brought into the emergency department can indeed determine whether he will live or die. He's in immediate danger of suffocation, massive blood loss, and any number of complications from associated injuries.

So in those first few minutes you will be doing a sort of balancing act, exercising your best judgment to decide what to do first and how to do it. Some things that *look* urgent can be put off. Others demand immediate attention because they threaten the patient's life.

"It's a matter of doing first things first," says Dr. Gilbert G. Eade, a Seattle plastic surgeon who is chairman of the American College of Surgeons' state committee on trauma for Washington. "The most important thing is to be sure the patient is breathing. If not, why not? You also have to be sure his heart is beating, of course, but it doesn't do any good to get his heart beating if you can't get air in and out. And you've got to control any obvious bleeding."

And while all this is going on, don't forget to ask "what happened." This is all too frequently overlooked. Dr. Eade told the Canadian Society of Plastic Surgeons. "The guy arrives in the emergency room with a battered face and a cut head," he says, "and what you don't know is that he rolled down a 150-foot embankment and hit his head on a rock at the bottom. Often a patient is brought in and just dumped, and the people who brought him aren't questioned and they don't stay around. By this time he may be unconscious and all opportunity for finding out how the accident happened has been lost. And 'what happened' often is the only clue to 'what should I look for.'"

You may be too busy in those first few minutes to spend time on history taking, so someone in the emergency room should be trained to extract all available information from whoever brings the injured person in—the minute he's brought in. Be sure the person assigned to this vital job has firmly in mind that a trauma victim may also have a sensitivity or allergy to medication, he may be a diabetic or epileptic, may be taking various drugs or have other problems, any one of which may confuse or compound care if they're not known.

Opening the airway will sometimes take nothing more than clearing out any debris that may be blocking it—clots, loose teeth, foreign bodies, broken dentures. The tongue may be displaced backward; bring it forward and hold it by a heavy suture, a towel clip, or even a safety pin through its tip. You may have to use suction to remove blood and secretions. It also

makes sense to place the badly injured patient in the semiprone position, or with his head turned sideways, to permit gravity drainage—but always think "broken neck" when turning the head or trunk.

But what if these relatively simple measures just don't do the job?

"My first preference is intubation," says the Seattle plastic surgeon, "but this is never really easy in the patient with a badly smashed face, and sometimes it's impossible. The patient's upper and lower jaws may both be broken, teeth and tissues dislodged, his neck may be badly swollen, and blood may be running into everything; it's a real problem to get an airway you can rely on. If the patient is really struggling for air, his brain is becoming hypoxic; he'll be thrashing around all over the place and there's no way you'll ever intubate him. But I still won't attempt even a low conventional tracheostomy. It's impossible to do as a true emergency procedure without proper equipment, without adequate light, without assistance, and with a lot of bleeding and the patient thrashing around. Instead I'll do a cricothyrotomy. It's a simple, safe procedure, easily and quickly done, and it's immediately effective."

The cricothyrotomy is purely a temporary expedient. Once the incision is made, Dr. Eade puts a tube in to hold it open. "It can be almost anything," he says, "a real short tube, if one is handy, *continued*

EMERGENCY MEDICINE / APRIL 1973

63

Art Directors *Ira Silberlicht/Tom Lennon*
Photographer *Shig Ikeda*
Agency *Fischer Medical Publications, Inc.*
Client *Emergency Medicine Magazine*

Fewer acute attacks of gout with

ColBENEMID®

Each tablet contains 0.5 Gm
probenecid and 0.5 mg colchicine

Probenecid • helps reduce serum uric acid levels • helps prevent or delay the formation of crippling tophi.

Colchicine • although not an analgesic, produces dramatic relief of pain in acute attacks of gout • helps lengthen intervals between acute attacks

NOTE: ColBENEMID® is indicated in the treatment of all stages of gout and gouty arthritis; however, it should not be started during an acute attack. While hypersensitivity to probenecid may occur during continuous therapy, it is more likely to occur with intermittent use. The appearance of reactions may require cessation of therapy or dosage reduction.

Indications: Gout and gouty arthritis except a presenting acute attack. However, if an acute attack is precipitated during therapy the drug should be continued without changing the dosage, and additional colchicine should be given to control the acute attack.

Contraindications: Hypersensitivity. Not recommended in persons with blood dyscrasias or uric acid kidney stones.

Warnings: In rare instances, hematuria, renal colic, and costovertebral pain have been reported. May precipitate an acute attack of gout; theoretically, may favor urate stone formation, which may be prevented by alkalization of urine and liberal fluid intake. When alkali is given, acid-base balance should be watched. Salicylates should not be given with probenecid, since coadministration results in inhibition of the uricosuric activity of the latter. Cell division in animals and plants can be arrested by colchicine. In certain species of animal under certain conditions colchicine has produced teratogenic effects and has adversely affected spermatogenesis. Such effects have not been demonstrated in humans.

Precautions: Hypersensitivity may occur, especially with intermittent use, requiring cessation of therapy or dosage reduction. Since probenecid raises plasma level of conjugated sulfa drugs, plasma concentrations should be checked occasionally during prolonged coadministration with sulfa drugs. A reducing substance, which disappears with discontinuance of therapy, may appear in the urine, giving a false-positive Benedict's test.

Adverse Reactions: Probenecid: Occasionally, headache, gastrointestinal symptoms (e.g., anorexia, nausea), increased urinary frequency, and hypersensitivity reactions including dermatitis have appeared. Rarely, flushing, dizziness, anemia, and anaphylactoid reactions. Hemolytic anemia, which in some instances may be related to a genetic deficiency of glucose-6-phosphate dehydrogenase in red cells. Extremely rare instances of nephrotic syndrome, hepatic necrosis, and aplastic anemia.

Colchicine: G.I. disturbances (e.g., nausea, vomiting, abdominal pain, diarrhea), particularly troublesome in presence of peptic ulcer or spastic colon. Toxic doses may cause severe diarrhea, generalized vascular damage, and renal damage with hematuria and oliguria. Muscular weakness, which disappears with discontinuance of therapy, urticaria, dermatitis, and purpura may occur and may require reduction of dosage or discontinuation of drug; prolonged use may cause agranulocytosis, aplastic anemia, peripheral neuritis. Loss of hair has been reported. In hepatic dysfunction, consider possibility of increased colchicine toxicity.

Supplied: Tablets, containing 0.5 Gm probenecid and 0.5 mg colchicine each, in bottles of 100.

For more detailed information, consult your Merck Sharp & Dohme representative or see the package circular.

MERCK SHARP & DOHME Division of Merck & Co. Inc. West Point Pa 19486

WHERE TODAY'S THEORY IS TOMORROW'S THERAPY

ColBENEMID for gout and the pain of gout

Art Director *Sal Morello*
Photographer *Carl Fischer*
Copywriter *Norman Franklin*
Agency *Robert A Beckler, Inc.*
Client *Merck, Sharp and Dohme*

Silhouette

Profile views and silhouettes—graphic techniques traceable to the cave paintings—are still one of the most effective, quick impact, visual communication tools. A Step Further technique you can try is to look for two or more silhouettes that can be combined to create a unique design. Check your Word Association Lists carefully, and try all possible Random Linking combinations.

Art Director *Joseph M. Essex*
Illustrator *Joseph M. Essex*
Copywriter *Tom Horiwitz*
Agency *Bunson•Marsteller/Design Group*
Client *Cloud Hands*

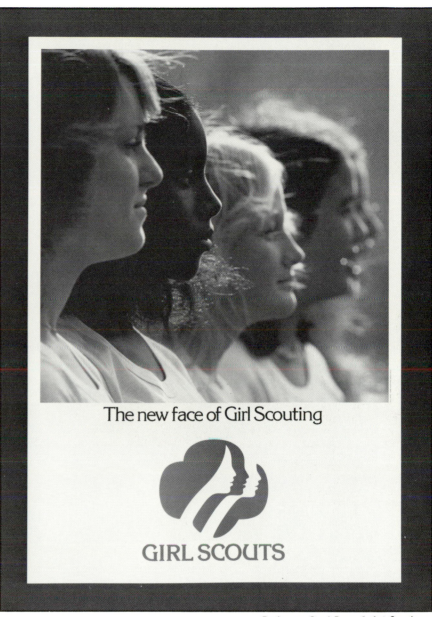

The new face of Girl Scouting

GIRL SCOUTS

Designers *Saul Bass & Art Goodman*
Photographer *Arnold Schwartzman*
Agency *Bass/Yager & Assoc.*
Client *Girl Scouts of U.S.A.*

Art Director *David Zeigerman*
Copywriters *Allan R. Wahler, Steve Klausen*
Agency *Corporate Design Group, Inc.*
Client *Cardinal Type Service*

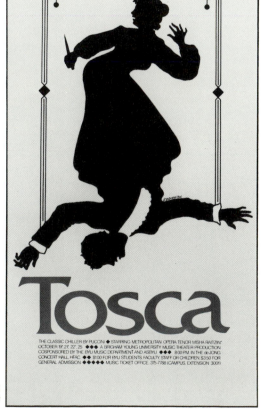

Art Director *McRay Magleby*
Illustrator *Ronald Eddington*
Copywriter *Ronald Eddington*
Agency *Graphic Communications*
Client *Brigham Young University*

Simplification

Will your message function best in an elegant setting? A majestic or understated one? Does your product require singular emphasis? Employ extreme simplicity—eliminate all details, focus on essentials, use lots of "empty" space or backgrounds.

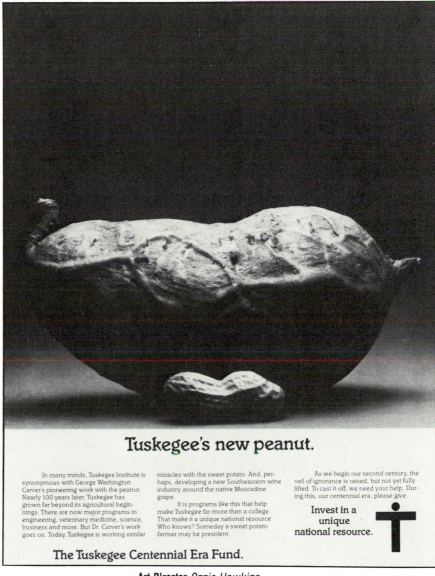

Tuskegee's new peanut.

In many minds, Tuskegee Institute is synonymous with George Washington Carver's pioneering work with the peanut. Nearly 100 years later, Tuskegee has grown far beyond its agricultural beginnings. There are now major programs in engineering, veterinary medicine, science, business and more. But Dr. Carver's work goes on. Today, Tuskegee is working similar miracles with the sweet potato. And, perhaps, developing a new Southeastern wine industry around the native Muscadine grape.

It is programs like this that help make Tuskegee far more than a college. That make it a unique national resource. Who knows? Someday a sweet potato farmer may be president.

As we begin our second century, the veil of ignorance is raised, but not yet fully lifted. To cast it off, we need your help. During this, our centennial era, please give.

Invest in a unique national resource.

The Tuskegee Centennial Era Fund.

Art Director *Ozzie Hawkins*
Photographer *Miguel Martin*
Copywriter *Bill Irvine*
Agency *J. Walter Thompson U.S.A., Inc.*
Client *Tuskegee Institute, William R. Simms, Associate Director*

Art Directors *Phil Marco & Morris Shriftman*
Photographer *Phil Marco*
Agency *The Morris Shriftman Co.*
Client *Tree of Life*

Stylization

Reduce the subject, object, or product to visual essentials: two-dimensional shapes and patterns. Emphasize design elements—rhythmic flow of lines, light and dark value sequences, repetition with variation. Or apply some of these design elements to a cartoon-style illustration.

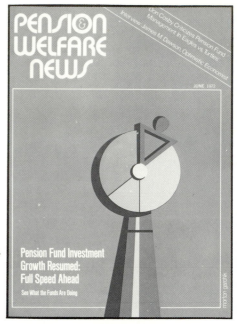

Art Director *Morton Garchik*
Illustrator *Morton Garchik*
Client *Communication Channels Inc.*

Art Director *Mike Mohamud*
Director *Eugene Kolamatsky*
Client *NBC*

Industrial
Launderer
March
1979

Art Director *Jack Lefkowitz*
Illustrator *Jack Lefkowitz*
Agency *Jack Lefkowitz Inc.*
Client *Institute of Industrial Launderers*

Art Directors *Albert Leutwyler/Oscar Schnider*
Illustrator *Kelly Kao*
Agency *Leutwyler Schnider*
Client *Benihana Restaurant*

Surrealism

Emphasize the classic elements of surrealist painting—the imaginative imagery of the unconscious; the fascinating incongruities of dream-logic; settings with deep-space perspective that suggest time-lessness—by giving wide scope to your Word Lists, Random Linking, Random Image Search, and Mental Doodling. (See also Fantasy, Metamorphosis, Visual Metaphors & Visual Puns.)

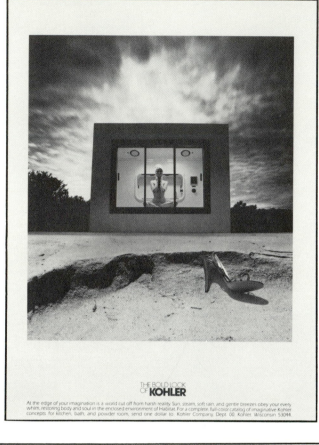

Art Director *Bob Jensen*
Photographer *Pete Turner*
Copywriter *Art Novak*
Agency *Campbell-Mithun,*
Inc.,/Minneapolis
Client *Kohler Company*

THE BOLD LOOK OF **KOHLER**

At the edge of your imagination is a world cut off from harsh reality. Sun, steam, soft rain, and gentle breezes obey your every whim, restoring body and soul in the enclosed environment of Habitat. For a complete, full-color catalog of imaginative Kohler concepts for kitchen, bath, and powder room, send one dollar to: Kohler Company, Dept. 00, Kohler, Wisconsin 53044.

Art Director *Leonard Restivo*
Photographer *Ryszard Horowitz*
Agency *In-house*
Client *Saks Fifth Avenue*

The Psychology of Scent...

by Dr. Fernando Aleu

Symbol Combinations

Combine visual symbols, of words from your Word Association Lists, to create interesting images. (In my "eagle" photo, the thermometer was a symbol for *hospital* and *illness* (from the Lists, under the heading Health); the eagle was a symbol for the words, *government* and *congress* (from the Lists, under the heading, National.) Try pushing One Step Further, by combining the symbols in an unlikely but logical way. See page 9 for step-by-step procedures.

Art Director *Morton Garchik*
Photographer *Morton Garchik*
Client *Communication Channels Inc.*

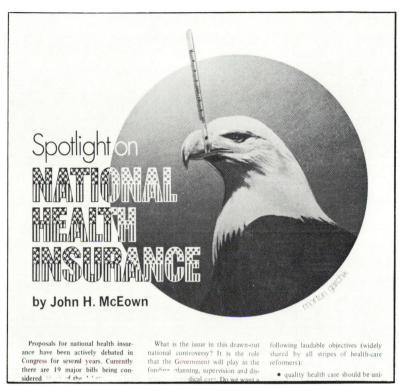

Spotlight on
NATIONAL HEALTH INSURANCE
by John H. McEown

Proposals for national health insurance have been actively debated in Congress for several years. Currently there are 19 major bills being considered ... of the ...

What is the issue in this drawn-out national controversy? It is the role that the Government will play in the funding, planning, supervision and dis... dical care. Do we want a ...

following laudable objectives (widely shared by all stripes of health-care reformers):
• quality health care should be uni-

Art Director *Margot Zalkind-Schur*
Illustrators *Margot Zalkind-Schur/Wendy Edelson*
Copywriter *Dorothy Rosa Leeds*
Agency *The Very Graphic! Design Co.*
Client *Goddard College, Vermont*

A WRITING PROGRAM FOR PEOPLE WHO LOVE TO WRITE

The Goddard Writing Skills Summer Program offers twelve weeks of intensive study in poetry, fiction, and composition for people who love to write and want to spend a summer in Vermont writing.

College students (and a limited number of qualified high school students) spend the summer working with recognized professionals in basic and advanced skills courses and in workshops covering a variety of creative forms. Because we know that good writers read, we ask them to select one or two literature courses to accompany their studies in writing. These courses include American Fiction: 1945-1975; Contemporary American Poets; Film and the Novel; Poetic Forms; The Poetry of Yeats; The Strategy of the Poem; and New Journalism: Politics in Literature.

Visiting poets, novelists, short story writers, editors, and agents will read and discuss their work.

If you like to write, and want to spend the summer writing, write to us for detailed information.

A WRITING PROGRAM FOR PEOPLE WHO HATE TO WRITE

The Goddard Writing Skills Summer Program offers twelve weeks of intensive study in writing for students who hate to write but have to.

People planning academic, business, or professional careers must be able to write clearly and effectively. We believe that the ability to do this is not inborn, and that good students with writing problems can, through sustained study and practice, learn to write well.

Through weekly individual conferences and courses and workshops in basic skills, creative writing, composition, and literature, the program provides opportunity for developing increased competence and confidence in written self-expression.

If you hate to write but know you have to, write for detailed information.

The Goddard College Writing Skills Summer Program
Box WS-4, Goddard College, Plainfield, Vermont 05667

FACULTY: John Dranow, Program Director; Pat Griffith, Richard Herrmann, Linda McCarriston, Kathryn Ungerer, Wayne Zade.

READINGS AND LECTURES: Tom Absher, poet; Ann Beattie, novelist and short story writer; Richard Ford, novelist; Louise Glück, poet; Donald Hall, editor and poet; Grace Paley, short story writer; Michael Ryan, poet, Ellen Voigt, poet; and Geoffrey Wolff, critic, biographer, and novelist.

June 4—August 24, 1979
15 Semester Hours Credit
Financial Aid Available

Goddard College admits students without regard to race, color, national origin, sex, or handicap.

Design: Margot Zalkind-Schur
Drawings: Wendy Edelson

Test of Credibility

If your product or subject has a remarkable claim, highlight it with a remarkable presentation. Guides for your Word Association should be: *spectacular, bravado, nth degree exaggeration,* and *visual hyperbole.* Go One Step Further and create an additional twist for the image you devise with the C.V.T. techniques. Example: you are promoting a powerful glue, and envision a photo of a camel (loaded down with bales of straw) standing on a scaffold, that is suspended from a beam, projecting over a mountain chasm. The scaffold, we learn from the copy, is attached to the beam by one drop of the power-glue. The One Step Further would be in the headline copy: "... one more straw might break the camel's back, but not the bond of 'power-glue' ..."

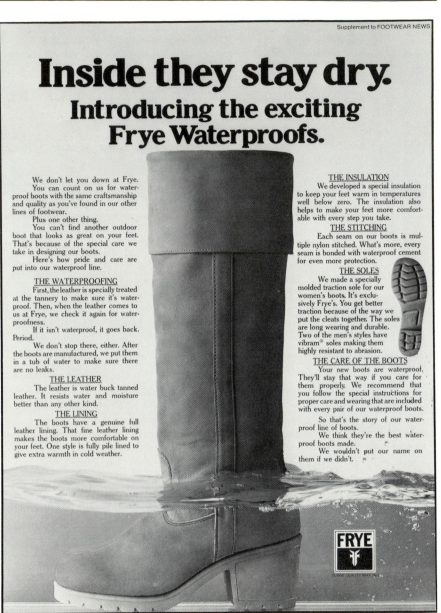

Art Director *Jerry Fremuth*
Photographer *Peter Elliot*
Copywriter *Tom Hansen*
Agency *Lee King & Partners*
Client *John A. Frye Shoe Co.*

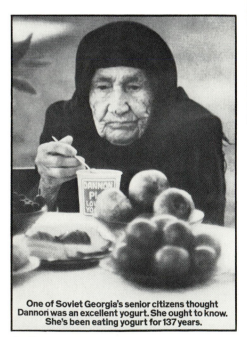

One of Soviet Georgia's senior citizens thought Dannon was an excellent yogurt. She ought to know. She's been eating yogurt for 137 years.

Art Director *Joseph Goldberg*
Photographer *Bob Gaffney*
Copywriter *Peter Lubalin*
Agency *Marsteller Inc. N.Y.*
Client *Dannon Yogurt*

Theme Device as Design Element _____

An approach with numerous applications: logo design, illustration, photography, packaging. Use the product itself as the dominant design element. That usage can range from realism to stylization. Your Word Association, Random Linking, and Random Image Search, should concentrate on a format that will integrate the product into a design; thus keep in mind such devices as: rhythm, pattern, repetition with variation, and stylization. Don't overlook simple or obvious Word Associations for clues.

Art Director *Joseph M. Essex*
Illustrator *Peter Crockett*
Agency *Burson . Marsteller/Design Group*
Client *Ace Chain Link Fence*

Art Director *Michael Richards*
Designer/Artist *Michael Mabry*
Agency *University of Utah Graphic Design*
Client *University of Utah Bookstore*

Art Director *D. Bruce Zahor*
Illustrator *D. Bruce Zahor*
Agency *Zahor Design Inc.*
Client *Command Travel Inc.*

Art Director *D. Bruce Zahor*
Illustrator *D. Bruce Zahor*
Agency *Zahor Design Inc.*
Client *International Women's Writing Group*

Art Director Morton Garchik
Illustrator Morton Garchik
Client Communication Channels Inc.

Art Director Mark Moffet
Photographer Art Associates Inc.
Copywriter John Siddall
Agency Siddall, Matus & Coughter Inc.
Client Gulf Reston, Inc.

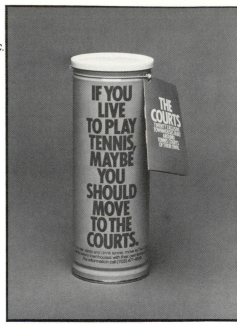

Art Director Steve Rutland
Photographer Parish Kohanim
Copywriter Ward Archer, Jr.
Agency Ward Archer & Assoc.
Client Seabrook Wall Coverings

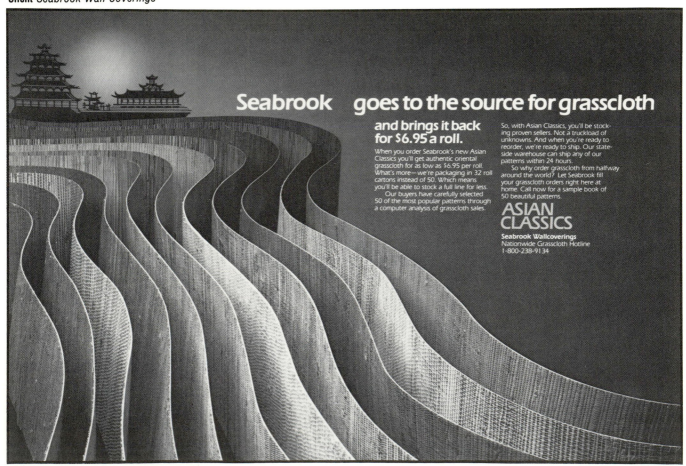

Three-Dimensional Illustration Techniques

Convert a prosaic assignment into an exciting one, by using the C.V.T. system to find a logical link to a three-dimensional illustration.

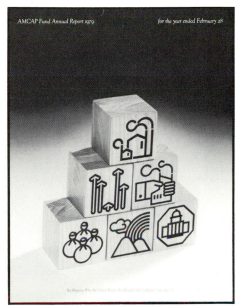

Art Director *Patrick Soo Hoo*
Photographer *Jay Silverman*
Illustrators *Patrick Soo Hoo, Phillip Komai*
Copywriters *Mary Ann Beebe, Peter Langer*
Agency *Patrick Soo Hoo/Designers*
Client *Capital Research & Management Co.*

Art Director *Steven Jacobs*
Illustrator *Pat Wilson*
Copywriters *Clark Wells*
Agency *Steven Jacobs, Inc.*
Client *L.B. Nelson Corp.*

Art Director *Stuart Kerner*
Photographer *Stefan Tessler*
Copywriters *Stuart Kerner, Arthur R. Trostler*
Agency *Mintzer, Trostler & Rothschild*
Client *Romeo y Julieta*

Unusual Production Techniques

Use computer-generated images, die-cuts, embossing, mezzotints & other line conversion methods, and off-beat folds for quick problem solving. Use the C.V.T. system to find an appropriate link between the subject and a particular technique.

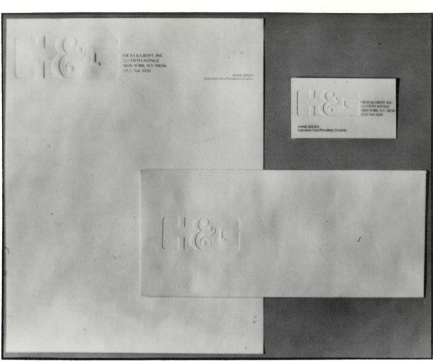

Art Director *Ralph Parenio*
Letterer *Sam Konowitz*
Agency *Hicks & Greist*
Client *Hicks & Greist*

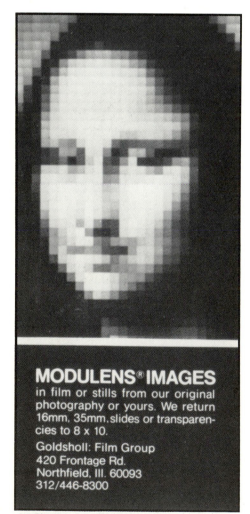

Art Director *John Weber*
Photographer *Harry Goldsholl*
Copywriter *Staff*
Client *Goldsholl Film Group*

Art Director *Morton Garchik*
Illustrator *Morton Garchik*
Client *Communication Channels Inc.*

Unusual Views

Avoid the commonplace by selecting a bird's-eye or worm's-eye view. Make use of wide-angle lenses; views through the "holes" of objects (doughnut-like forms or shapes); views between objects (two trees, legs, people). Or simply turn a photo or illustration off its normal axis.

Art Director *Vince Trippy*
Illustrator *Barry Jones Design Studio*
Copywriter *Vince Trippy*
Agency *KR Advertising*
Client *Koh-i-noor Rapidograph*

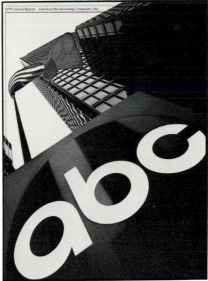

Art Directors *Aubrey Balkind, Phil Gips*
Designers *Phil Gips, Diana Graham*
Photographer *Steve Fenn*
Copywriter *Peter Hauck*
Agency *Gips + Balkind + Associates, Inc.*
Client *American Broadcasting Co.*

Art Director *Kirk Hinshaw*
Illustrator *John Casado*
Copywriter *David Hill*
Agency *Dancer, Fitzgerald, Sample, Inc./SF*
Client *Boise Cascade Corp.*

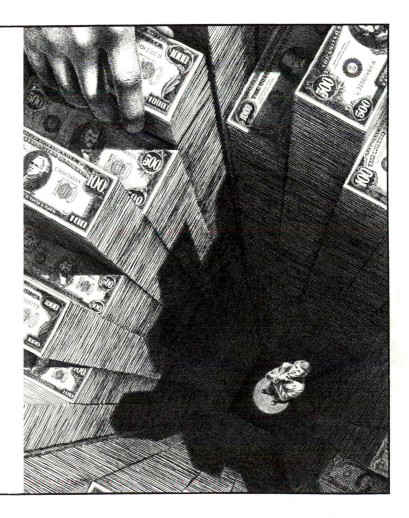

Visual Metaphors & Visual Puns

Create an interplay between the copyline and a visual metaphor. The Mental Doodling process should be guided by the similarity between images, objects, or products, which can be combined, altered or put in a new context to create a unique visual image. (See also Double Entendre, and in Chapter 1, Visual Metaphors & Visual Puns, for a step-by-step demonstration.)

Art Director *Stan Zimmerman*
Photographer *Jayrod Studios*
Copywriter *Ellen Voisin*
Agency *Stan Zimmerman, Inc./Advertising*
Client *Chain Italia, Ltd.*

CHAIN ITALIA DOES PROVOCATIVE THINGS WITH 14K AND 18K GOLD.

A touch of Venus . . . the golden touch of Chain Italia. Artistry that goes to her head. That interprets her desire to dazzle, distract, devastate. And makes her want to wrap herself in our chains of 14K and 18K gold. Chain Italia reflects her lifestyle and her image. It's the line that delivers gold chains her way and delivers sales your way. And with Chain Italia, you get what you order. Fast. So, see us now. The sooner you show our chains, the sooner you'll sell them.

chain Italia LTD.

10 WEST 47TH STREET
NEW YORK, N.Y. 11036
(212) 575-6835

"We Deliver"

Art Director *Richard Kimmel*
Photographer *Dennis Manarchy*
Copywriter *Martin Cooke*
Agency *N.W. Ayer ABH International-Chicago*
Client *Illinois Bell Telephone Company*

Christmas Bells.

Art Director *Charles Piccirillo*
Illustrator *Charles Piccirillo*
Copywriter *Robert Levenson*
Agency *Doyle Dane Bernbach*
Client *Volkswagen of America*

Or buy a Volkswagen.

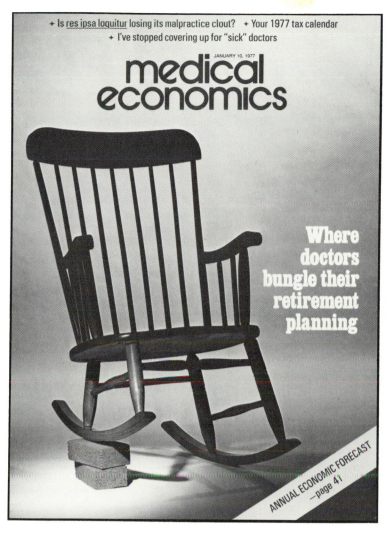

+ Is <u>res ipsa loquitur</u> losing its malpractice clout? + Your 1977 tax calendar
+ I've stopped covering up for "sick" doctors

JANUARY 10, 1977

medical economics

Where doctors bungle their retirement planning

ANNUAL ECONOMIC FORECAST
—page 41

Art Directors *Albert M. Foti & Willaim J. Kuhn*
Photographer *Stephen E. Munz*
Client *Medical Economics Magazine*

Art Directors *Peter Rogers, Len Favara*
Photographer *Richard Davis*
Copywriter *Heni Abrams*
Agency *Peter Rogers Assoc.*
Client *Danskin*

ENVIRONMENT

AT&T Department of Environmental Affairs

Human Resources and the
Service Commitment · Education · Corporate Relations and Responsibilities

Who will put it together again?

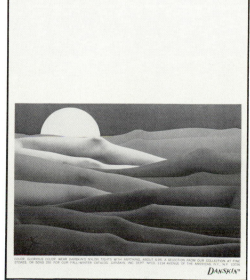

✗ DANSKINS ARE NOT JUST FOR DANCING

COLOR, GLORIOUS COLOR. WEAR DANSKIN'S NYLON TIGHTS WITH ANYTHING. ABOUT 4.95. A SELECTION FROM OUR COLLECTION AT FINE STORES, OR SEND 25¢ FOR OUR FALL-WINTER CATALOG. DANSKIN, INC. DEPT. NY10, 1114 AVENUE OF THE AMERICAS, N.Y., N.Y 10036.

DANSKIN'

Designers *Saul Bass & Art Goodman*
Photographer *George Arakaki*
Agency *Bass/Yager & Assoc.*
Client *AT&T*

Problems Solving Approaches (P.S.A.s) Copy Ideas

This section illustrates approaches in which the copy idea is foremost, with the visual lending its support.

While copy ideas are primarily the domain of creative directors, copywriters, editors, and account executives, many art directors have a flair for creating them. Often an art director's ability to suggest the changing of a word or short phrase in an assigned headline is the key to her/his creating an exciting visual (see Visual Metaphors & Visual Puns, Chapter 1).

Artists who do not have this skill will find it a valuable one to develop. The Creative Visual Thinking system, detailed in Chapter 1, and study of the examples in this chapter, will help in that development.

Bearding the Lion in its Den

Flaunt the success of your product right in the competition's own backyard! A rare but highly effective Problem Solving Approach.

Art Director *Bert Steinhauser*
Photographer *Bert Steinhauser*
Copywriter *Robert Levenson*
Agency *Doyle Dane Bernbach*
Client *Volkswagen*

RABBIT. THE #1 SELLING IMPORT IN JAPAN.

The Japanese obviously know a good thing when they see one.

And so more people in Japan are buying Volkswagen Rabbits than any other imported car.

Fascinating. But not astonishing.

The Rabbit has more total room than any Japanese car in its class.

The Rabbit hops from 0 to 50 mph in 8.3 seconds.

Most Japanese cars don't.

If you're interested in superior handling and maneuverability, you'll get them in a Rabbit, because the Rabbit has front-wheel drive.

Most Japanese cars don't.

If you're interested in economy, a VW Rabbit with a diesel engine got the highest mileage of any car in America for 1978: 53mpg on the highway, 40mpg in the city.

The gasoline Rabbit is no slouch, either, with 38mpg on the highway, 25mpg in the city.

(EPA estimates, with standard transmission. Your own mileage may vary, depending on how and where you drive, your car's condition and optional equipment.)

In short, the Rabbit delivers precisely what thoughtful people anywhere want in a car: performance, room, handling, economy.

So next time you have a yen for a terrific sukiyaki dinner, drive to the restaurant in a Rabbit. And enjoy the best of both worlds.

VOLKSWAGEN DOES IT AGAIN

Compelling Human Interest

When the subject of your assignment is profoundly persuasive in itself, let it speak for itself. No high-powered layout, no hyperbolic copy.

Art Director *Frank Young*
Photographer *Alan Zindman*
Copywriter *Regina Ovesey*
Agency *Public Service Advertising System/ School of Visual Arts*
Client *President's Committee on Employment of the Handicapped*

Carlos Martinez is determined to move ahead at Manufacturers Hanover Trust. He has Muscular Dystrophy.

Carlos studied accounting at Long Island University, one of the most accessible schools for the handicapped. The Office of Vocational Rehabilitation sponsored his college education. With the help of a job placement counselor at the Institute of Rehabilitative Medicine, he got the interview which led to his present job as term loan analyst at Manufacturers Hanover Trust. He checks up on the finances of companies seeking loans from the bank for both the national and metropolitan divisions.

Carlos has applied for the management training program. He hopes eventually to hold an executive position in the bank. "Certainly being in a wheelchair hasn't helped me any," says Carlos. "You definitely have to strive harder than the average person."

Carlos does volunteer work for the Muscular Dystrophy Association. Right now he is co-ordinating a special project for the Association's Lower Manhattan Task Group, encouraging people with muscular dystrophy to discuss issues that affect them and to write letters to their representatives urging affirmative action. "I guess our position is analogous to the blacks in the civil rights struggle," says Martinez. "We're fighting to make other people aware that we have the same desires as they do, that we're not really different."

Carlos Martinez was born in Puerto Rico. When his older brother started to fall repeatedly and have difficulty getting up, his parents did not know what was wrong. When the whole family moved to New York, both brothers were checked by doctors. "But," Carlos says, "they didn't have the equipment they have now. There weren't any muscular dystrophy clinics. The disease was difficult to diagnose, and they didn't know what we had until eight years later."

President's Committee on Employment of the Handicapped Washington, D.C. 20210
The School of Visual Arts Public Advertising System

Art Director *Dan A. Bixler*
Photographer *Hans Rott*
Copywriter *Jan Heath*
Agency *Juhl Advertising Agency, Inc.*
Client *Upjohn Healthcare Services*

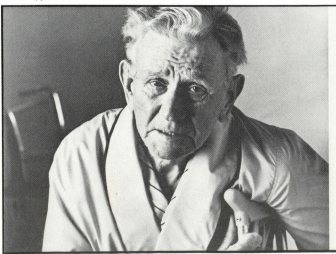

"How can I go home? There's nobody there."

The patient is ready to be discharged, yet not fully ready to care for himself. What do you recommend to him?

A skilled nursing facility or extended care facility may not be the answer. He may need more care—or less—than institutions ordinarily offer. If so, perhaps you should introduce him to home health care from Upjohn HealthCare Services℠.

We're a service program of The Upjohn Company, worldwide developer and manufacturer of ethical pharmaceuticals. For almost a decade, we have shared the Upjohn commitment to providing the highest quality health care possible.

Our service is a reliable source of home care personnel, including RNs, LP/VNs, nurse assistants, home health aides and companions. Whether the patient needs round-the-clock nursing, or simply help with meals and other day-to-day tasks, we can provide the appropriate level of care.

And whether the patient's home is in town or a thousand miles away, chances are there's an Upjohn HealthCare Services office nearby. We have over 240 offices throughout the United States and Canada, and we'd like to send you a complete office directory. Just send us the attached card. Or, call the Upjohn HealthCare Services office nearest you. We're listed in your telephone directory.

UPJOHN HEALTHCARE SERVICES™
Formerly HOMEMAKERS UPJOHN®

Double Entendre & Puns and Word Play

In the Double Entendre approach you use the C.V.T. techniques to find an image that gives a second meaning to a well-known phrase, slogan, proverb, etc. (see also Twisting). Work backwards: Word Associate to the product and relevant information about it, then do research for a related line, using your Word Lists for clues to the Double Entendre Image.

The Puns and Word Play approach can lead to catchy headlines. It requires extensive Word Association and Random Linking plus related research; in the hypothetical example that follows, the area to research would be music—anything and everything you can find.

Your assignment is a hi-fidelity equipment ad. Your Word Lists (under music) would contain the titles of famous operas, including, "Boris Gudunoff," (which has a built in pun—*good enough*), and the word *sound* (under the List heading, Hi-Fidelity). It would not take much Mental Doodling to come up with a line like, "... *Boris* not *sounding Gudunoff* on your old equipment, come in and try our Hi-Fi, etc...."

Art Director *John Eding*
Photographer *Larry Robins*
Copywriter *Doug Houston*
Agency *Doyle Dane Bernbach*
Client *Volkswagen*

"They just don't build Volkswagens like they used to."

We build them better.

Take safety. Underneath the hood you'll find a safety feature you wouldn't dream of finding in most cars:

Holes.

They're specially designed using a computer, so the front end will help absorb energy in the event of a collision.

We also developed such things as an "independent stabilizer rear axle," which increases the stability of the car on rough roads.

And for our deluxe Rabbit, we developed special seat belts that actually put themselves on when you close the door.

Hardly a detail escaped our attention. Even the ignition key is padded for safety.

What about room? It's probably not the first thing you think about when you say "VW."

Yet today, Volkswagens actually have more combined interior room and trunk space than most other cars in their class.

Rabbits are so roomy they're being used as taxicabs in Lexington, Kentucky. In fact, Rabbits have more interior room than 25 other cars you could buy. And more trunk space than a Cadillac Seville.

They're also surprisingly quick, with acceleration from 0 to 50 mph faster than a Triumph Spitfire.

Which brings us to another subject: performance.

Our Scirocco can take you from 0 to 50 in an amazing 7.5 seconds. And last year it was the Trans Am Champion in the under-2-liter class.

What's more, our newest Volkswagens are among the few cars in the world that combine front-wheel drive (for improved tracking), fuel injection (for smooth acceleration), an overhead cam engine (for sportier performance), front disc brakes (for controlled stopping), and rack-and-pinion steering (for incredible response).

Do we still sound like the VW you remember?

Well then, take a look at our station wagon.

We never made anything like our Dasher wagon before. With more cargo room than any other wagon in its class. With a plush interior and carpeting all around.

And in our beautifully appointed 2-door or 4-door sedans, Dasher has more room than most American cars in its class.

Yet, with all the changes we've made, some things always remain the same.

We still employ 13,500 inspectors to insure the quality of every car we make.

And much of our work is still done by hand.

Like the paint. It's hand sprayed, over and over. It's hand sanded and hand cleaned. It's even checked by people wearing special mittens. And before it's finished it's put through 29 individual steps of preparation.

There's also that familiar "jingle" you get putting money in the bank. Because all three Volkswagens get 24 MPG in the city. Rabbit and Scirocco get 37 MPG on the highway. Dasher gets 36. (EPA estimates with standard transmission. Actual mileage depends on how and where you drive, optional equipment and the car's condition.)

Volkswagens aren't sounding like Volkswagens of the past.

They're sounding more like cars of the future.

Rabbit

Scirocco

Dasher

Economy without sacrifice

Joint savings account.

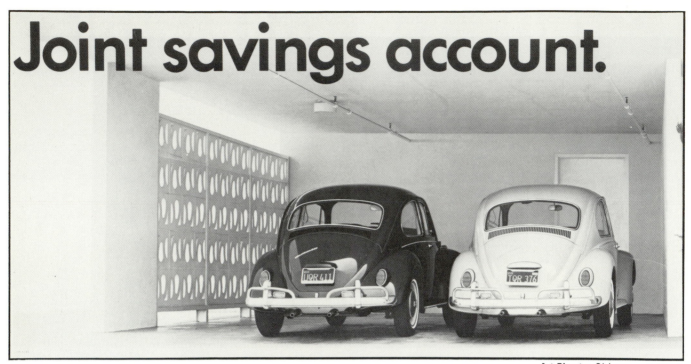

Art Director *Si Lam*
Photographer *Bernard Gardner*
Copywriter *Ron Levin*
Agency *Doyle Dane Bernbach*
Client *Volkswagen of America*

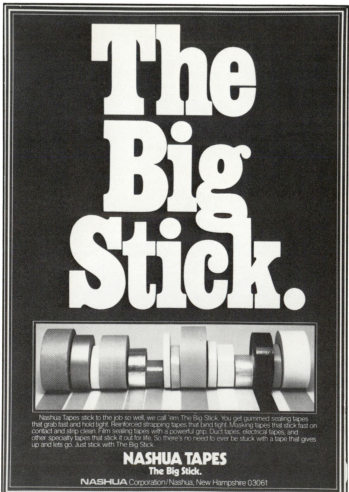

The Big Stick.

Nashua Tapes stick to the job so well, we call 'em The Big Stick. You get gummed sealing tapes that grab fast and hold tight. Reinforced strapping tapes that bind tight. Masking tapes that stick fast on contact and strip clean. Film sealing tapes with a powerful grip. Duct tapes, electrical tapes, and other specialty tapes that stick it out for life. So there's no need to ever be stuck with a tape that gives up and lets go. Just stick with The Big Stick.

NASHUA TAPES
The Big Stick.

NASHUA Corporation/Nashua, New Hampshire 03061

Art Director *Stavros Cosmopulos*
Photographer *Bob O'Shaugnessy*
Copywriter *Stavros Cosmopulos*
Agency *Arnold & Company*
Client *Nashua Corporation*

2²/₃ LB. PER PERSON, TRIPLE OCCUPANCY.

We want you to camp in comfort. So we designed our versatile Three-Man tent with maximum use of interior space and secure protection from all weather situations. Plus, it's only 8 lb. total weight.

Go ahead, stand up in it. It's a great place to spend a stormy day. Even packing and pitching are easy, it's ideal for backpacking or fishing trips and family camping.

After 10 years the Three-Man is still the most popular large tent among backpackers. All our products carry Lifetime Seam Protection Guarantee. You can inspect our tents at specialty wilderness shops. Write for the name of your nearest dealer. Sierra Designs, 247 Fourth Street, Oakland, CA 94607.

SIERRA DESIGNS THREE-MAN

We pay through the hose

if our master power steering assortment doesn't give you coverage and fit for any sale.

E. Edelmann is so confident that our new E-201-3 assortment will cover all your application calls, we make this unprecedented profit indemnification guarantee:

If you ever lose a power steering hose assembly sale through inadequate coverage or improper fit for any passenger car cataloged by us, we will pay you -- in cash -- for the profit you would have realized on that lost sale.

In other words, if we've goofed, it will cost us, not you. Anytime it happens.

For details on our guaranteed profit assortment, contact our representative, or write: E. Edelmann & Co., 4711 Golf Road, Skokie, Ill 60076. **E. Edelmann & Co.**

With Mobil 1 you can eliminate at least 2 oil changes a year.

Spend less time in the air.

Switching to Mobil 1 is a good way to keep your car where it belongs. On the ground.

If you've been changing your oil the way most people have (every 4 to 6,000 miles) Mobil 1 could take you much farther and eliminate at least 2 oil changes a year. You could rack up a total of 15,000 miles or go a full year, whatever comes first, before you have to put your car up on the rack for an oil change. (If your car is still under warranty, you should change your oil in accordance with warranty requirements.)

The oil that saves you gas.
Mobil 1 cuts friction so well it actually takes the average car up to 10 extra miles on a tankful of gas.

The oil that saves you oil.
Since Mobil 1 doesn't evaporate as rapidly as ordinary oil you should be using less oil. (Provided, of course, that your engine is in good mechanical condition.)

Better in hot and cold weather.
Mobil 1 is a synthesized engine lubri-

cant that outperforms premium motor oil all seasons of the year. Since Mobil 1 doesn't thicken up as much as ordinary oil in cold weather, you'll be getting easier cold weather starts. Mobil 1 can actually help your car get started in temperatures as low as 35 degrees below zero.

Mobil 1 doesn't thin out the way ordinary oil does in hot weather, either. It continues to spread a better protective film over the moving parts of your engine, even in the hottest days of summer.

Better engine protection.
To prove how good our oil really is we ran Mobil 1 in a car for 15,000 miles, adding oil as needed. Incredible as it may seem, tests showed that after 15,000 miles of driving, used Mobil 1 still protected the engine as well as brand new premium motor oil!

So if you're up in the air about which oil to buy, come down to earth. Buy Mobil 1.

The oil that saves you gas
...saves you oil changes.

Endorsement

Use your Word Association Lists, Random Linking, and Mental Doodling as guides to the appropriate twist, which will give this classic approach extra punch: humor, uniqueness, relatedness.

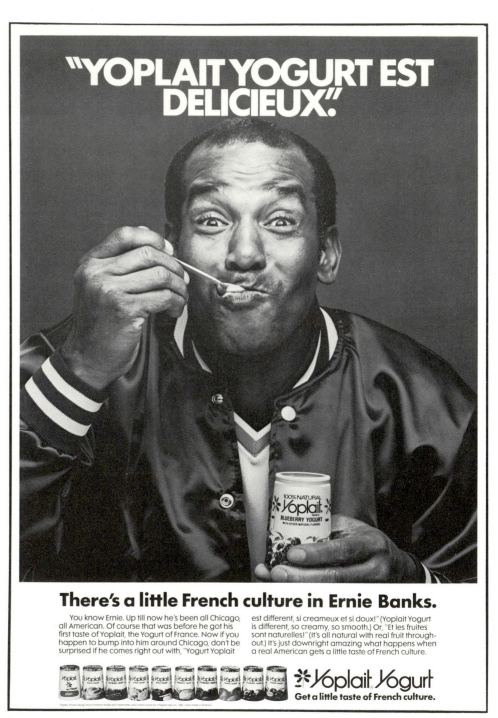

"YOPLAIT YOGURT EST DELICIEUX."

There's a little French culture in Ernie Banks.

You know Ernie. Up till now he's been all Chicago, all American. Of course that was before he got his first taste of Yoplait, the Yogurt of France. Now if you happen to bump into him around Chicago, don't be surprised if he comes right out with, "Yogurt Yoplait est different, si creameux et si doux!" (Yoplait Yogurt is different, so creamy, so smooth.) Or, "Et les fruites sont naturelles!" (It's all natural with real fruit throughout.) It's just downright amazing what happens when a real American gets a little taste of French culture.

Yoplait Yogurt
Get a little taste of French culture.

Art Director *Jean Govoni*
Photographer *Carl Fischer*
Copywriter *Cliff Freeman*
Agency *Dancer Fitzgerald Sample*
Client *Yoplait, USA*

Keep 'em Reading

Entice the reader into this approach—with its emphasis on copy—by Word Associating and Random Linking, to find an intriguing format: charts, educational information, games, teasing headlines, comparison tests.

Art Director *William J. Square*
Photographers *Dennis Iannarelli, Gary Klous*
Illustrators *Tery Pazcko, Vladimir Kordls*
Copywriter *Gerald Tolle*
Studio *Falcon Advertising Art*
Agency *Sapin & Tolle/Wyse Advertising*
Client *TRW Inc.*

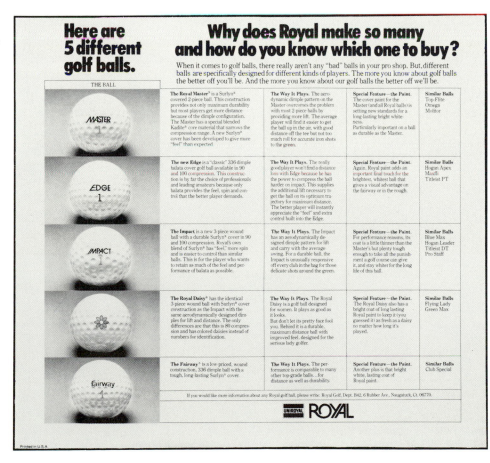

Art Director *Herb Jager*
Photographer *Ulf Skogsberg*
Copywriter *Chester Gore*
Agency *Chester Gore Company Inc.*
Client *Uniroyal Inc.*

Joyce Philips doesn't know her ascenders from her descenders.

So what makes her one of the world's great typesetters?

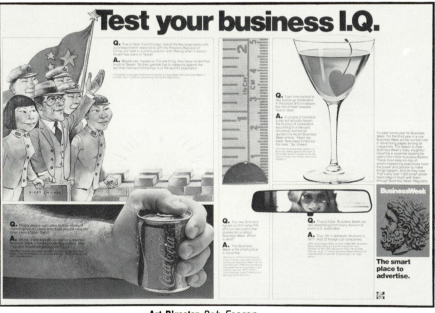

Test your business I.Q.

BRING MOM AND DAD TO CAMP THIS SUMMER

Literal Translation

A simple approach: make a direct visual translation of the headline copy or story elements (see also Symbol Combinations page 68).

Art Director *Morton Garchik*
Illustrator *Morton Garchik*
Client *Communication Channels Inc.*
(Editorial Illustration for
'Fund Managers Competing for the Same Dollars.')

Art Director *John Johnson*
Illustrator *Bruce Wolfe*
Agency *Paul Pease Advertising, Inc.*
Client *Snow Lion*

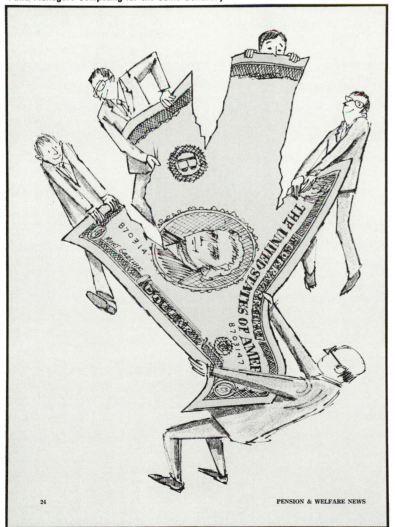

24 PENSION & WELFARE NEWS

Food Prices

P&WN: *Do you think it will be necessary to control food prices?*

Backman: I do not believe it is possible to control food prices effectively. Perishability, variety in quality, large numbers of outlets, the desire to obtain foods considered necessary for family well-being, and related factors have always made a farce of food price control. I see no reason to believe that human nature has changed to a degree that would make it possible to control food prices more successfully than in the

Art Director *Morton Garchik*
Illustrator *Morton Garchik*
Client *Communication Channels Inc.*

Art Director *Bob Bidner*
Illustrator *Bob Bidner, Tony Toscano*
Copywriter *Ray Baker*
Agency *Ted Bates & Co., Inc.*
Client *Julius Wile Sons & Co., Inc.*

Art Director *Manny Kurtz*
Illustrator *Morton Garchik*
Client *UAHC*

Art Director *Morton Garchik*
Photographer *Morton Garchik*
Client *Conover-Mast*

Art Director *Morton Garchik*
Illustrator *Morton Garchik*
Client *Communication Channels Inc.*

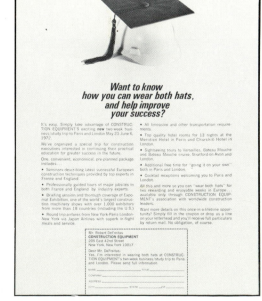

Naming Names

In Bearding The Lion, the concept can function without specifically naming the competition. In this approach the competitor's name is stated head-on.

Try walking into Merrill Lynch and asking for Mr. Lynch.

Try going into Thompson McKinnon and asking for Thompson or McKinnon. Try calling Chase Manhattan and asking for Mr. Chase.

You won't get them.

Instead, you'll often end up talking to someone who's thinking as much about his own job outlook as your financial outlook.

Try calling Goldberg Polen & Co.

At Goldberg Polen & Co., we operate on a different principle.

When you deal with Goldberg Polen & Co., you'll be dealing directly with Goldberg and Polen themselves. Benefiting directly from their years of experience on Wall Street and in every area of the financial field.

What's more, you can rest assured that when you deal with any member of our staff, you'll be dealing with someone who has met our rigorous standards and is more than fully qualified to serve your needs.

You can also rest assured that you'll continue to have access to Goldberg and to Polen. They're committed to a close, long term personal relationship with their clients. They won't suddenly disappear, because their names are on the door.

We do more than just recommend stocks.

As we've said, Goldberg Polen & Co. operates on a different principle.

We believe in total financial planning. Although few people seem to understand this idea, it's the only way important financial goals have a chance of being achieved.

At Goldberg Polen & Co. we do more than recommend which stock

to buy or which stock not to buy. We slowly and carefully formulate a balanced financial program based on your own special needs and goals, whether you're an individual or a corporation. Including not just stocks and bonds, but estate planning, insurance, annuities, and most important, tax planning, the cornerstone of any soundly conceived financial plan.

Every decision or recommendation we make is determined solely by what's in your best interest. Long term as well as short term. Not by how much we can make on the transaction. Because we know that putting your interest ahead of our own is better for us both in the end.

Goldberg Polen & Co. is located at 14 East Central Avenue, Spring Valley, N.Y. Our number is 914-356-2900. If you're genuinely and seriously interested in forging a sound financial program for yourself, give us a call.

Just ask for Mr. Goldberg or Mr. Polen.

GOLDBERG POLEN AND COMPANY, INC.

Art Director *Paul Jervis*
Photographer *Paul Jervis*
Copywriter *Marc Shenfield*
Agency *Direct*
Client *Goldberg/Polen*

Art Director *Jack Anesh*
Photographer *Hal Davis*
Copywriter *Ned Viseltear*
Agency *Anesh, Viseltear, Gumbinner Inc.*
Client *Oscar de la Renta Menswear*

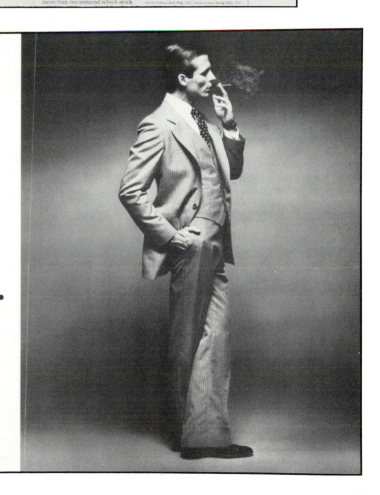

Goodbye Yves St. Laurent, Pierre Cardin, Nino Cerruti.

Hello Oscar de la Renta.

American men have had it with the harsh, extreme European silhouette. (Most of them couldn't squeeze into it anyway.)

They're going back—for keeps, we think—to classic, understated, elegant, wearable clothing.

And no one is more closely or favorably identified with that kind of clothing than Oscar de la Renta.

The Spring '78 line he just completed for us proves that he is, indeed, the king of classic designers.

The line is, in a word, magnificent. The best expression of the traditional soft shoulder British silhouette we've ever seen.

And we're not the only ones who think so.

Almost everyone who's seen it has bought it. Usually in depth.

Superb styling. Exquisite detailing inside and out. Oscar de la Renta signature lining and label. Fabulous fabrications that are ours and ours alone.

Based on a keystone plus markup, the suits will retail from $185 to $225, sport coats from $125 to $150. But everything looks like it costs a lot more.

If we sound excited it's because we are. And you will be too, when you've seen the line.

Because you won't just be looking at Oscar de la Renta's superb work.

You'll be looking at the future of men's clothing.

DESIGNS FOR LOUIS GOLDSMITH
1290 Avenue of the Americas, New York City (212) 581-9533

Nostalgia

Use the Creative Visual Thinking system to find images, subjects, ideas, and styles that evoke people's penchant for the "good old days," and the "they don't make them like they used to" products.

Art Director *Ron Anderson*
Photographers *Tom Berthiaume, Rick Dublin*
Copywriter *Tom McElligott*
Agency *Bozell & Jacobs/Mpls MN*
Client *Northwestern Bell*

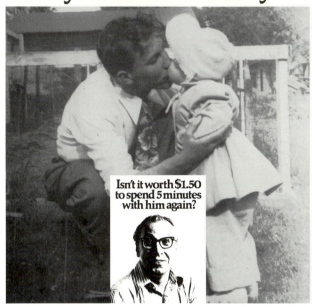

In 1947, your dad always found time for you.

Isn't it worth $1.50 to spend 5 minutes with him again?

Remember the great times you had together? Staying in touch regularly with old friends and loved ones costs less than you think.

For example, for under $1.50* you can talk for a full five minutes on the telephone to New Orleans, New York, or Seattle, evenings after

5 PM and anytime on weekends. So go ahead, relive those old memories and plan for new ones. On the telephone.

For calls direct dialed without operator assistance and charged to the phone you're calling from. Rate applies in those communities where direct dial facilities are not available. Rate shown includes taxes.

 Northwestern Bell

Art Director *John C. Jay*
Illustrator *Michael Doret*
Agency *In-house*
Client *Bloomingdale's*

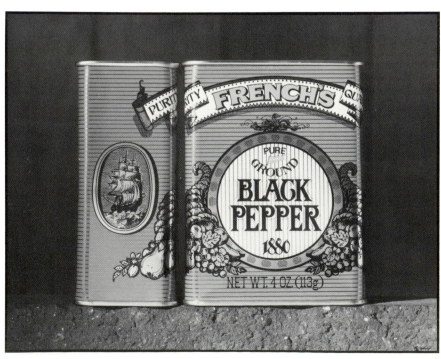

Art Director *Edward C. Kozlowski*
Lettering & Illustration *Thaddeus Szumilas*
Agency *Edward C. Kozlowski Design, Inc.*
Client *R.T. French Co.*

Tall Tales

Compose an intriguing or humorous narrative. Do your Word Associating and Random Linking against research of famous historical events, or well-known stories, which can be related to the subject and be parodied.

Designer *Dave Lewis*
Art Directors *Dave Brown, Jim Adair*
Illustrator *Pierre Le Tan*
Copywriter *Doug Pippin*
Agency *Geer, Dubois*
Client *William Grant & Sons*

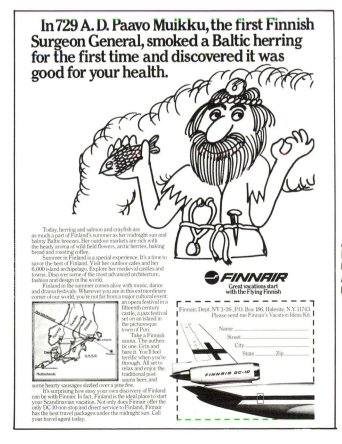

Art Director *Larry Hamniond*
Illustrator *Alan Zwiewbel*
Copywriters *Tim Warriner/Barry Crane*
Agency *D'Archy-MacManus, Masius/de Garmo*
Client *Finnair*

Twisting

This P.S.A. requires extensive literary research—cliches, names, proverbs, titles, well-known sayings, and rhyming words—before implementing the C.V.T. techniques. (See also Double Entendre & Puns and Word Play.)

Make lists of famous or current titles (books, films, plays, songs, TV shows, etc.)

Make lists of famous quotations and proverbs.

Make lists of the names of famous people.

Make lists of current slang phrases and popular jargon.

Next, do your List Scanning and Mental Doodling, with an eye to finding a homonym for a word in the quotation, which will give the "twisted" quote a new meaning when read in conjunction with a picture of the product. Other procedures:

A quotation, kept intact, but coupled with a picture of the product, creates a new meaning for both.

Look for an "opposite"—the opposite of a word in a quote, which, when substituted for the original word and joined with a photo of the product, creates a new meaning.

Even a random selection of "quotations," not directly related to the words in your assigned copy headline, can sometimes be utilized to great effect—with the proper twist. Example: Your assignment is a story, tentatively titled, "Marathon Medics," about doctors, specializing in the treatment of runners. Suppose you had on your Random List of famous quotes, "Survival of the Fittest." Just a little Mental Doodling would lead you to this catchy Twist: "Revival of the Fittest."

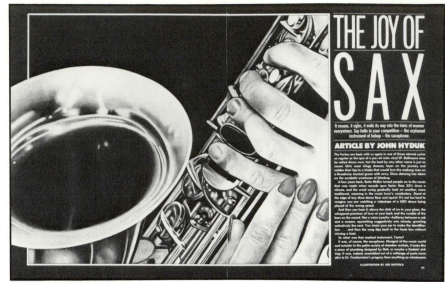

Art Director *Michael Brock*
Designer *James Kiehle*
Illustrator *Joe Saffold*
Client *Oui Magazine*

Art Director *Helmut Krone*
Photographer *Wingate Paine*
Copywriter *Julian Koenig*
Agency *Doyle Dane Bernbach*
Client *Volkswagen of America*

Art Director *Mike Leon*
Photographer *Cosimo*
Copywriter *Erica Heller*
Agency *Doyle Dane Bernbach*
Client *Volkswagen*

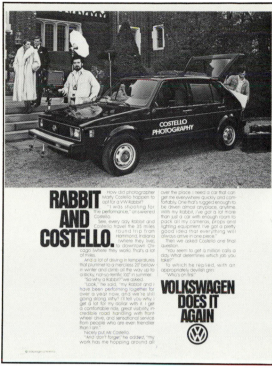

Art Director *Les Affonso*
Photographer *Bill Wagner*
Copywriter *George Meredith*
Agency *Gianettino & Meredith, Inc.*
Client *Welsh Farms*

(The agency has a policy of not supplying individual names since there is an emphasis on teamwork.)
Agency *Grey-Phillips, Bunton, Mundel & Blake (PTY) Ltd.*
Client *Hampo Trading*

Chapter 4

Problems Solving Approaches (P.S.A.s)
Typographic Ideas

The Creative Visual Thinking system can help artists (and writers) who have no type design or lettering skills to solve typographic problems.

The studying of the P.S.A.s in this chapter and the application of the step-by-step process, detailed in Chapter 1, to these categories, will help *guide your thinking* to specific typographic solutions. Then a modest "rough" of your creative type idea can be turned over to a specialist for a finished rendering.

Don't regard these approaches as remote from those in Chapters 2 and 3, but rather as additional choices in another mode. If you are not given limitations with an assignment, don't impose them on yourself. Turning to a typographic solution, for example, when a photo or illustration image might have been the obvious choice, is a creative first step in itself.

Abstracting Letter Forms

Simplify and adapt letter forms into basic design shapes: circles, ovals, triangles, or rectangles. If you have two or more, combine them into one design shape.

Art Director *Oskar Blotta*
Illustrator *Oskar Blotta*
Agency *Badillo/Compton, Inc.*
Client *Asoc. de Radio Difusores*

Art Director *Jim Lienhart*
Agency *MWDL & Assoc.*
Client *Allan Cox & Assoc.*

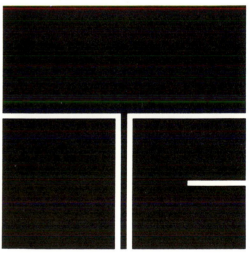

Art Director *James Laird*
Agency *James Laird Design Inc.*
Client *ITC*

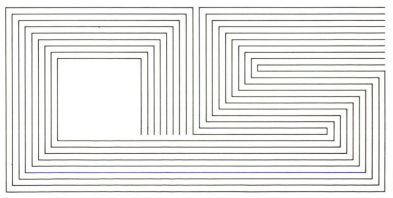

Art Director *Mark Goldstein*
Client *Opto-Systems, Inc.*

Letter Combinations & Ligatures

While retaining their basic character, join two or more letters, so that they form a unit.

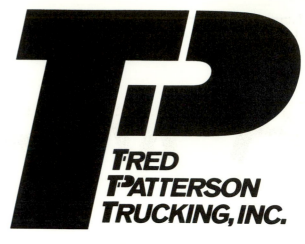

Art Director *Morton Garchik*
Agency *Medallion Assoc.*
Client *Fred Patterson Trucking, Inc.*

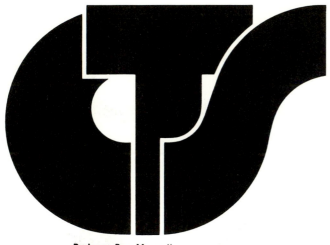

Designer *Don Mennell*
Client *Cardinal Type Service*

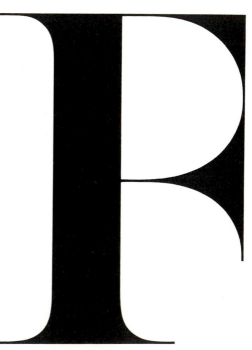

Art Director *Morton Garchik*
Client *Pelham House Inc.*

Art Director *Herb Lubalin*
Agency *Herb Lubalin Assoc., Inc.*
Client *Finch Pruyn Paper Co.*

Emphasize the design possibilities
of letters that resemble each other.
Some examples:

AV MEW CU

hy nu db qp

WW

Art Director *David M. Reed*
Illustrator *David M. Reed*
Agency *Reed Kaina Schaller Advertising, Inc.*
Client *Wirtz-McCarthy Associates*

ZENITH
SECURITIES LTD.

Art Director *Morton Garchik*
Client *Zenith Securities Ltd.*

Now You See It, Now You Don't _____

Entice the viewer to puzzle out a fascinating typographic image by designing a sequence of letters, whose "positive" and "negative" shapes interchange their functions.

Art Director *Carl Seltzer*
Studios *Advertising Designers, Inc; Terry Utterback & Assoc.*
Agency *T. Utterback & Assoc.*
Client *First Los Angeles Bank*

Art Director *Herb Lubalin*
Agency *Herb Lubalin Associates, Inc.*
Client *Zebra Assoc.*

Supergraphics

Go all out with type—a word, a letter form, or a typographic device (! " " # $ % & * ¢ ? etc.) that dominates the layout.

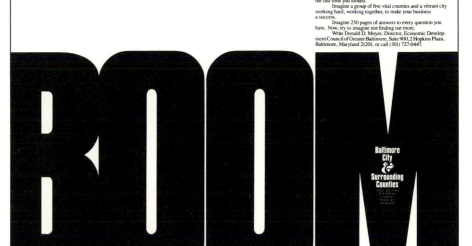

Imagine a place where $1 billion in outside capital has been invested in the last six months.

Imagine a skyline of office buildings, hotels, shopping malls, convention facilities, and industrial parks that didn't exist the last time you looked.

Imagine a group of five vital counties and a vibrant city working hard, working together, to make your business a success.

Imagine 250 pages of answers to every question you have. Now, try to imagine not finding out more.

Write Donald D. Moyer, Director, Economic Development Council of Greater Baltimore, Suite 900, 2 Hopkins Plaza, Baltimore, Maryland 21201, or call (301) 727-0447.

Art Director *Don Schramek*
Copywriter *Troy Lumpkin*
Agency *Vansant, Dugdale & Co.*
Client *Dept. of Economic & Community Dvpt., State of Maryland*

Art Director *Jim Adair*
Copywriter *Steve Olderman*
Agency *Geer, Dubois Inc.*
Client *Time, Inc.*

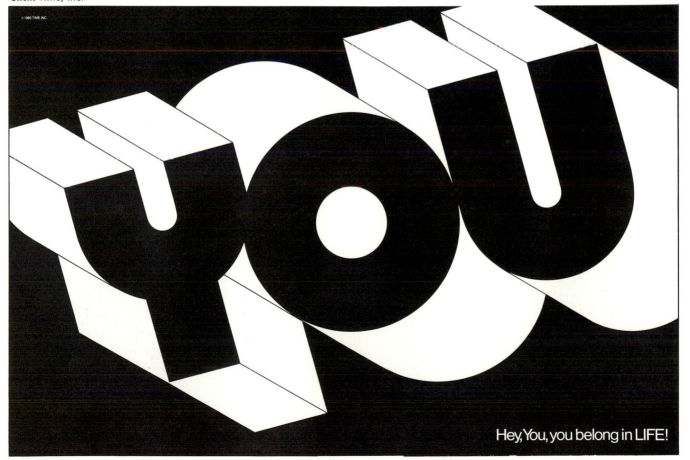

Hey, You, you belong in LIFE!

Three-Dimensional Type

As a change of pace from conventional type, use real or simulated three-dimensional type forms to express a specific theme, product, or material.

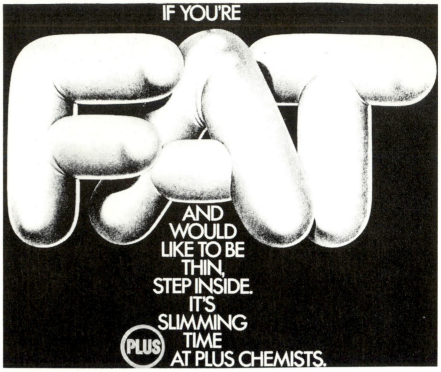

(The Agency has a policy of not supplying individual names since there is an emphasis on teamwork.)
Agency Grey-Phillips, Bunton, Mundel & Blake (PTY) Ltd.
Client Plus Chemists

Art Director Peter McGuggart, Compton Advertising
Designers Roger Cook/Don Shanosky
Photographer Arthur Beck
Copywriter David Brown
Agency Cook and Shanosky Associates, Inc.
Client IBM, Compton Advertising

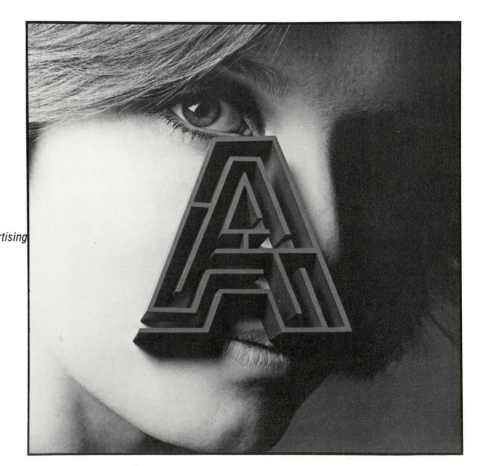

Type As Object, Object As Type

Scan your Word Association Lists for an object that can substitute as a letter in a word. Or design letters or words as an object or objects. (See Chapter 1 for a step-by-step example.)

Creative Director *John Chervokas*
Art Director *Charles Givarino*
Photographer *Andrew Unangst*
Copywriter *Don Lauve*
Agency *Warwick, Welsh & Miller*
Client *Seagram's*

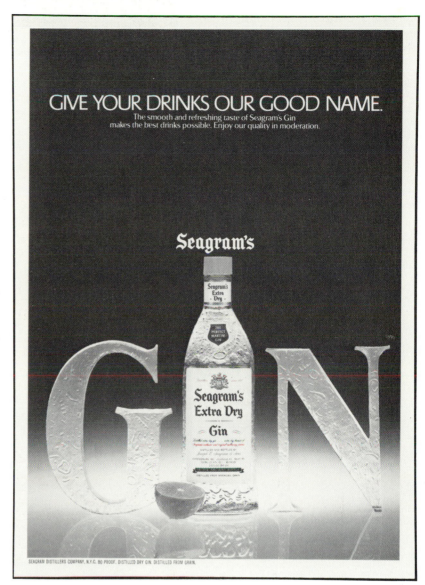

Art Director *Michael Richards*
Designer/Artist *Bill Swensen*
Agency *University of Utah Graphic Design*
Client *University of Utah Ballet School*

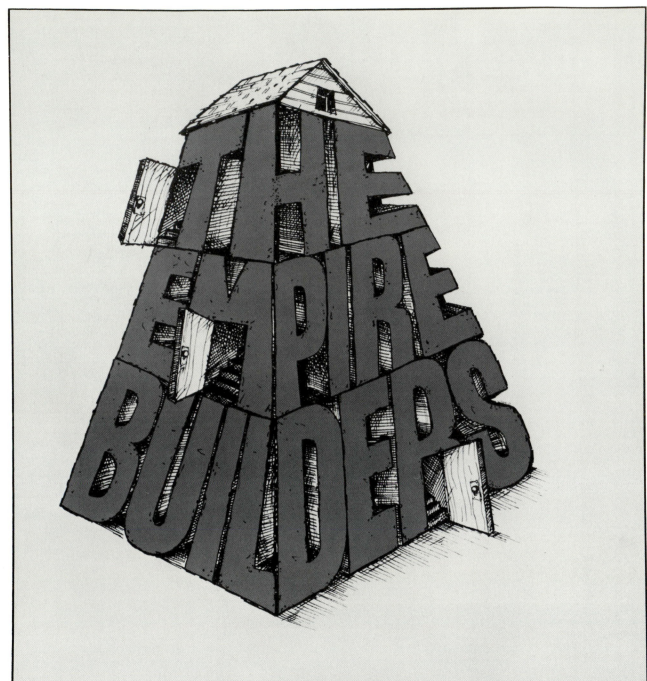

BY BORIS VIAN
TRANSLATED FROM THE FRENCH BY SIMON WATSON TAYLOR
DIRECTED BY WILLIAM DOBKIN

SEPTEMBER 28-OCTOBER 1, 5-8 • 8 PM • LYCEUM THEATRE • TICKETS $1, $2 & $3
ASU UNIVERSITY THEATRE BOX OFFICE: 965-3437

Art Director *David A. Knox*
Illustrator *David A. Knox*
Agency *Bureau of Publications*
Client *University Theatre, Arizona State University*

Type in an Environment

Do your Word Associating and List Scanning with an eye towards creating a related environment into which you can place type.

Art Director *Nickolas Dankovich*
Photographer *Charlie Coppims*
Client *The Plain Dealer Magazine*

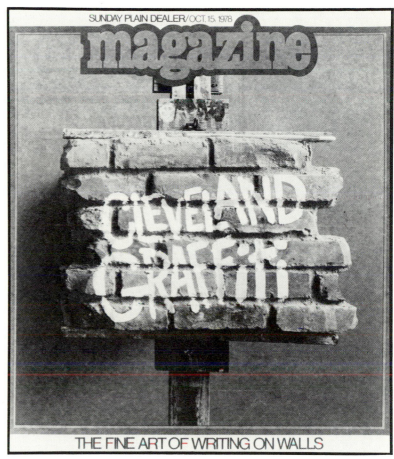

Art Director *Ed Nussbaum*
Photographer /Illustrator *Ed Nussbaum*
Agency *Self Promotion*
Client *Ed Nussbaum*

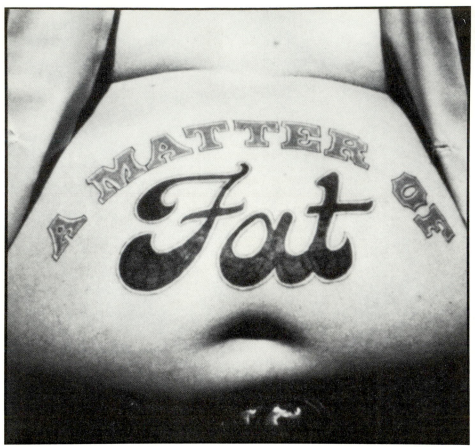

Art Director *Dennis W. Bender*
Photographer/Illustrator *Dennis W. Bender*
Agency *WPSX-TV*
Client *WPSX/Programming Dept.*

Art Director *Dick Behm*
Photographer *Bender Hickson*
Designers *Dick Behm, Doug Fisher*
Copywriter *Kathy Bowen*
Agency *Lord, Sullivan & Yoder*
Client *Marion Arts Festival*

Type Integrated into an Image _____

Word Associate, List Scan, and Link Randomly to find a related image, or object, to which you can graphically attach type.

Art Director *Lou Dorfsman*
Designer and Artist *Peter Katz*
Agency *CBS Broadcast Group*
Client *CBS Sports*

Art Director *Herb Lubalin*
Lettering *Tom Carnase*
Agency *Herb Lubalin Assoc., Inc.*
Client *Metromedia*